THE
WATERCOLOUR
COMPANION

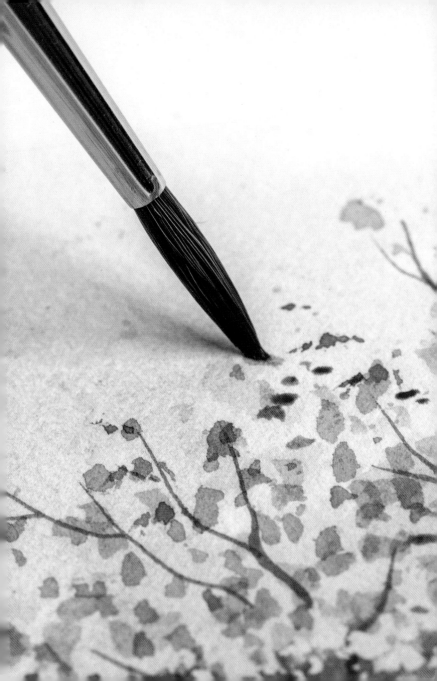

THE
WATERCOLOUR
COMPANION

TECHNIQUES & TIPS TO
IMPROVE YOUR PAINTING

Dedication

This book is dedicated to all the artists
I've taught over the years – and all those
yet to come.

Painting basics

Getting started 6
Preparing paint 8
What are key mixes? 10
Water and flow 12
Test your strength 14
Brushes and brushmarks 16
What paper? 18
Selecting colours 20
Adding more paints 22

Planning successful pictures

Using the picture finder 24
Working from photographs 26
What to paint? 28

Skies and light

Clear sky 30
Fresh cloudy sky 32
Evening sky 34
Key mixes for shadows 36
Sunset 38
Silhouettes 40
Moonlit sky 42
Stormy sky 44
Rainfall 46

Flowers

Masses of flowers 48
Daisies 50
Foxgloves 52
Poppies 54
Carpet of bluebells 56

Trees and woodlands

Trees in your paintings 58
Midground trees 60
Key mixes for spring foliage 62
Cherry blossom 64
Distant woodland 66
Key mixes for summer foliage 68
Palm trees 70
Trees in rows 72
Key mixes for autumn foliage 74
Branches 76
Woodland 78

Building and mountains

Buildings in the landscape 80
Stonework 82
Doorways 84
Architectural accuracy 86
Rocks and cliffs 88
Mountains 90
Snow-capped peaks 92

Water and the sea

Key mixes for the sea 94
Waves and sea spray 96
The beach 98
Reflections 100
Boats 102

People and wildlife

Key mixes for skintones 104
Figures in your pictures 106
Adding a sense of life 108
Stag in woodland 110
Small animals 112
Animals in the landscape 114
Kingfisher 116

Watercolour secrets and special effects

Falling snow 118
Fixing cauliflowers 120
Splashes and splatters 122
Leaf stencils 124
Beams of light 126

Glossary 128

Contents

GETTING STARTED

This book is the pocket guide you always wanted by your side during your watercolour adventures. It is packed with the colour mixes you need, along with quick references and advice for all common watercolour situations. It takes all the strain out of painting, leaving just the fun!

Using this book

Imagine yourself in your studio, wondering how to paint a particular style of tree, wanting to create a more dynamic sky, or struggling to work out what colours you need to capture that town hall or picnic spot you admire every time you pass. Whatever part of the landscape you want to paint, all you need to do is find the right page and you'll find my tips, ideas and advice on painting it.

Picture finder

Tucked into the pocket at the back is my handy picture finder. This versatile little tool is my 'Swiss arty knife' – it will help you with checking scale when out and about; identifying particular colours; finding the right format and angle for your painting, and much more. You can read more about it on page 24.

Key mixes

The hardest part of watercolour to get right, especially for beginners, is working out which paints to combine to make the colours in front of you – and how much water to add to ensure it's neither too strong, nor too pale. Throughout this book, you'll see the exact mixes I've used for the paintings shown, so you can compare what's on your palette and paper with what's on mine. Read about key mixes on page 10.

Preparing paint

These pages explain the basic principles that are used throughout the book, so practise the lessons here to gain the benefits later on. The notes here make clear the method I use for mixing colours, so they're **useful for both beginners and experienced artists** to try.

Watercolour works by floating pigments in the paint on water. As the water dries, the particles of pigment settle on the surface. The skill is in making sure the colours end up both where you want them, and at the right strength.

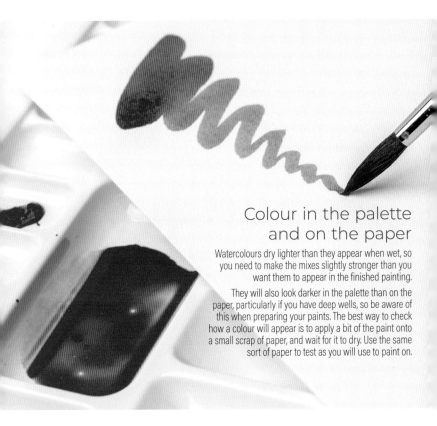

Colour in the palette and on the paper

Watercolours dry lighter than they appear when wet, so you need to make the mixes slightly stronger than you want them to appear in the finished painting.

They will also look darker in the palette than on the paper, particularly if you have deep wells, so be aware of this when preparing your paints. The best way to check how a colour will appear is to apply a bit of the paint onto a small scrap of paper, and wait for it to dry. Use the same sort of paper to test as you will use to paint on.

Tubes and pans

Watercolours are available in tubes of soft colour or as hard pans.
Both need to be prepared before use.

TUBE WATERCOLOUR

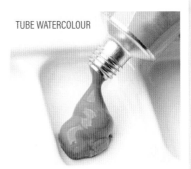

PAN WATERCOLOUR

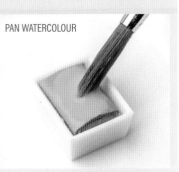

Tubes To prepare watercolour paint from a tube, simply squeeze out a small amount onto your palette, then use your brush to transfer it to a mixing well. Straight from the tube, the paint will be thick, and it needs a little water to be added before you can use it to paint. Use your brush to carry over the water to the mixing well, and stir it with the brush to mix the water and paint together.

Pans Pans are solid blocks of watercolour pigment. You need to wet your brush, then gently agitate the surface of the pan by rubbing it. You then wipe the brush into a well to deposit the paint, and repeat. Use just a tiny amount of water on your brush as you prepare the paint – you can dilute it further later on.

How much water?

For the moment, aim for a stiff mix that allows you to combine the colours and get things moving: add just one part water to nine parts paint. Barely fluid, this consistency will give stark, bold results; and hold some shape if you add another colour to the brushstroke while it is wet.

PREPARED PAINT

This **strong** brushstroke was made with paint diluted to 1 part water to 9 parts paint.

1:9

1 part water to 9 parts paint.

What are key mixes?

Until you get some experience with watercolour under your belt, it can be tricky to avoid pale, insipid results, for the wet paint in your palette won't match the dry colour. To help you avoid that, and get great results every time, **key mixes** pop up throughout the book to give you options and ideas for particular scenes or effects. They show you:

- Which paint colours you need
- How much of each paint to add
- How the wet paint should look in your palette well
- How it will look on your paper once dry.

With this information, you'll be able to reliably mix and re-mix the key colours you need every time; both to copy the paintings in this book and to create your own compositions.

You might find it handy to test your colour mixes on a bit of spare paper beforehand.

Training your eye

In addition to the big key mixes, I've included smaller ones specific to certain paintings to help you if you want to try copying them. You'll spot places where similar mixes have been used for quite different purposes. A sandstone mix is perfect for skin in shadow, for example – so there's no need to reinvent the wheel: I've just given you the same combination for each picture. Keep an eye out and you will start to see how you can use mixes in quite unexpected places.

Reading the key mixes

A list of the colours used, along with how much of each to use in the mix.

SPRING GREEN SHADOW

- **5** parts lemon yellow
- **4** parts French ultramarine
- **1** part alizarin crimson

The outer circle shows the pure colours in the right proportions. Here you can see that there's far more yellow than blue, and only a touch of red.

The inner circle shows the mix as it appears wet. Aim to recreate this in your palette well.

The bar shows how the mix will appear on your paper, once it has dried.

Using the key mixes indoors

Hold your palette next to the wet mix – the inner circle – to compare and check you've got the the colour mix right.

To help ensure you've got the right result, you can hold the book up to your painting to check it against the dry colour of the bar.

Using the key mixes outdoors

You'll notice the dry mixes extend right the way to the edge of the paper – this will allow you to hold up the page to objects near or far to gauge which mix is closest to what's in front of you. You might find a perfect mix – and if it needs adjustment, you've got a close mix to start from.

If you're in a hurry, or trying to catch something fleeting, like the colour of a sunset, take a photograph; you can compare the key mix to your picture later.

Water and flow

Part of the appeal of watercolour is that it is transparent; which means that light goes through the watercolour pigment and reflects back from the paper surface, giving the finished painting a bright, luminous finish.

Rather than using a single thick coat of paint, we can build up **subtle layers of colour** to get the strength and effect we want. To do this effectively, we need to be able to understand how much water to add to our paint.

Consistency and tone

Adding water to paint has two effects. Firstly, **water alters the consistency**, making the paint move more easily. This makes it less easy to control and place where you want, as it will move until the water dries.

Secondly, adding **water alters the tone** of the colours: the more water, the lighter the tone. This is because the same amount of pigment is spread out further.

You need fluid, pale paints to allow colours to blend and merge; and strong types for impact – not to mention to avoid drips. Note also the change in tone. **Stronger consistencies appear darker in tone; paler consistencies appear lighter.**

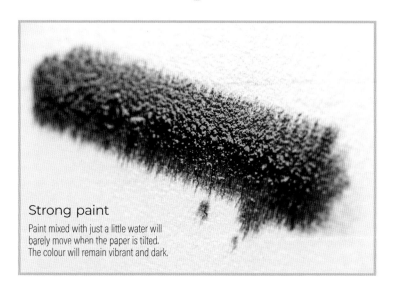

Strong paint

Paint mixed with just a little water will
barely move when the paper is tilted.
The colour will remain vibrant and dark.

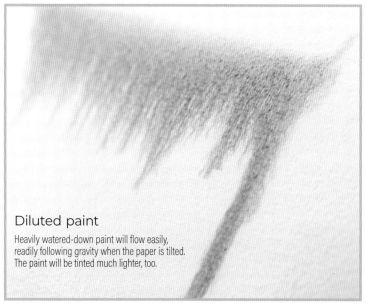

Diluted paint

Heavily watered-down paint will flow easily,
readily following gravity when the paper is tilted.
The paint will be tinted much lighter, too.

Test your strength

Taking account of the effects of consistency and tone (see page 12) is essential in planning and working with watercolour. To help you throughout the book **I break my paint mixtures into five consistencies**, shown here. Each involves adding a particular proportion of water to the mix of paint. As described on page 9, mix your colour in your palette first, using just enough water to combine any colours, then add the proportion of water described.

To test that you've got the consistency right, make a brushstroke on a spare piece of paper, and hold the edge of the book up to compare with the colour bars on the opposite page. If they match, you've got it right. If not, try adding more paint or more water until the consistency appears correct.

Throughout the book, each mix includes the consistency to show how I used it for that particular painting.

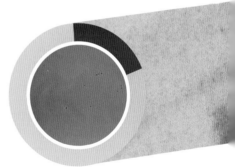

BRIGHT SPRING GREEN extra strong

- **8** parts lemon yellow
- **2** parts French ultramarine

Some paintings use the same mix at different strengths. Where this is particularly important I have included both types as key mixes — but there's no need to make separate wells. Start with the stronger mix, then add more water or paint as required.

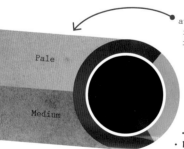

Pale

Medium

SHADOW GREY pale and medium

- **6** parts French ultramarine
- **3** parts yellow ochre
- **1** part alizarin crimson

Extra strong 1 part water to 4 parts paint.

Fluid enough to flow but strong enough to stand out, this consistency is great for adding **clean, clear marks** and **fine detail**.

`1:4`

Strong 2 parts water to 3 parts paint.

With only slightly more paint than water, this is fluid enough for painting **large washes** without the risk of brushmarks, while remaining strong enough to create bold areas of colour.

`2:3`

Medium Equal parts water and paint.

An even mix of water to paint is useful to give colours a little more body than a pale **wash**; or to tone down very dominant colours more than a strong consistency would allow.

`1:1`

Pale 3 parts water to 2 parts paint.

Heavily diluted, this is ideal for creating mobile, **fluid washes** or **subtle effects** that allow you to work over them easily.

`3:2`

Extra pale 4 parts water to 1 part paint.

This is used for very **thin glazes**, where you need to build things up gradually, or for very subtle effects.

`4:1`

Brushes and brushmarks

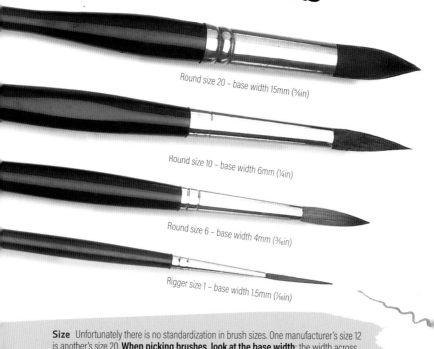

Round size 20 – base width 15mm (⅝in)

Round size 10 – base width 6mm (¼in)

Round size 6 – base width 4mm (³⁄₁₆in)

Rigger size 1 – base width 1.5mm (¹⁄₁₆in)

Size Unfortunately there is no standardization in brush sizes. One manufacturer's size 12 is another's size 20. **When picking brushes, look at the base width**: the width across the brush where the bristles meet the metal ferrule.

Hair Brush hairs are made from different materials, both natural and man-made. Synthetic bristles are the lowest cost but keep a good point and are long-lasting. Sable, the most expensive, are made from pure animal hair. Their hollow fibres hold more water than synthetic bristles. **My preference is for a sable/synthetic mix**, which balances the benefits of each hair type and will maintain a nice point.

Using the body of the brush allows you to cover large areas quickly.

Fine marks can be made with even a large round brush – so long as it has a good pointed tip.

Brush types

There are many specialist brushes, like my own Tree & Texture brushes, each designed for a specific purpose to make your painting life easier. These are nice to have, but it is best to **get comfortable with the basics** before experimenting.

The four brushes here are all you need for the vast majority of paintings. Once you have got comfortable with these, feel free to try out some others.

Round brushes are the classic and most all-round useful type. Round brushes hold paint in their belly, and come to a fine point.

Rigger brushes were originally designed for painting rigging on boats. They have very long, fine bristles that carry lots of paint.

Riggers create clean, fine marks: the perfect detailer.

What paper?

As with all painting materials, I always favour keeping things simple. My recommendation is Not surface watercolour paper in a quarter imperial size – that is, 38 x 28cm (15 x 11in) – or roughly equivalent to A3 format.

Preparing your paper

Attach your paper to a wooden or stiff board on all four sides using a good-quality masking tape. This keeps the paper flat and tight.

Stretching paper is something I haven't done in years. If you use a good-quality paper at a weight of 300gsm (140lb) or more, it simply isn't required. Using cotton paper also eliminates the need for stretching.

Paper weight

Watercolour paper is graded by weight – grams per square metre (gsm) or pounds per ream. The lower the number, the lighter and thinner the paper. I recommend 300gsm (140lb) paper for general use.

Rough

Having deep divots in the surface, this paper allows a **good level of texture**. Some rough surface papers can be to hard to get clean lines on.

Hot-pressed

Sometimes labelled simply 'HP' or Smooth, this paper has no textured surface. **Good for super fine detail** and pencil or pen work, but having no texture means it is not great for landscapes.

Not

Short for 'Not hot-pressed', this is also sometimes called cold-pressed, or CP. This paper has a medium 'tooth', giving **just the right amount of texture** for landscapes while allowing for sharp edges.

My choice every time!

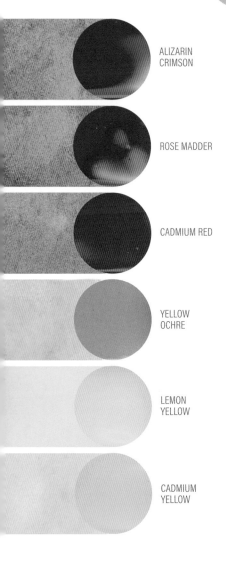

ALIZARIN
CRIMSON

ROSE MADDER

CADMIUM RED

YELLOW
OCHRE

LEMON
YELLOW

CADMIUM
YELLOW

Selecting colours

With hundreds of paint colours available, it's
sometimes difficult to know where to start.
I think it's best to get familiar with a small
number of paints and learn how you can use
them alone and in concert.

Key idea

Don't be fooled by how the paint appears when
wet in the well – it's how it appears on the
paper surface that's important.

The paints here are shown **as they appear
wet** in the palette well (in the circles) **and as
they appear dry** on the paper (in the bars that
touch the edge of the page).

All shown here are prepared to a **medium**
consistency (see pages 14–15). Try holding the
book up to your palette well to compare the
colours – if they don't match, adjust the amount
of paint or water in the well – then practise until
you can match them every time!

A basic palette

I recommend the paints shown here as a versatile starting palette, useful for all subjects and circumstances. My basic palette revolves around the **three primary colours**: red, yellow and blue. I have a couple of different options for each primary colour in my basic palette, allowing for great variety.

To this I add a purple, green and orange. These are **secondary colours**, and are useful starting points for lots of other mixes. Burnt umber is the final paint in my core palette – a versatile **earth colour** that works beautifully on its own, or combines well to make a range of dark mixes.

Opaque white

White paint isn't used to adjust the tone of your other colours. When working in watercolour, you add more water to the mix to make it lighter in tone (see page 12).

Instead, opaque white is used for overpainting: adding highlights over the top of darker paint – a white sheep in a field or a boat in a seascape, for example.

Opaque white is also great for adding final light touches to your painting – and if you have made a mistake, you can use white to cover it up.

CERULEAN BLUE

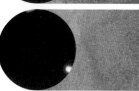

FRENCH ULTRAMARINE

PRUSSIAN BLUE

DIOXAZINE VIOLET

VIRIDIAN HUE

BURNT SIENNA

BURNT UMBER

Adding more paints

Tips from nature

Combining too many paints increases the proportion of impurities, leading to dull, muddy mixes. For this reason alone, it's good to **use as few paints in your mixes as possible** – rarely more than three. Sometimes, however, you want to mute or dull down a too-bright colour. Here, **premixed paints can help**, giving you control and consistency.

Natural Colour is a range of watercolour paints I have designed to replicate the colours found all around us in the landscape. Adding these extra colours to your core palette removes the need for excessive mixing, helping to keep the colours in your paintings clean and clear.

NATURAL GREY

Almost every painting of mine features a little of this, as it's the colour of shadows. Most greys contain black pigment which makes the shadows too loud and stand forward. A shadow needs to fall back. Mixed from the three primary colours, this soft hue causes the paint to recede, adding depth.

NATURAL ORANGE

Perfect for autumn foliage, skies at sunset and flowers, this orange can also be mixed with a touch of blue to make a rich dark green.

NATURAL TURQUOISE

Capturing the perfect seascape colour requires balancing vivid green and blue. This takes the struggle out – simply dilute it to pale or extra pale for distant seas and use a stronger consistency for close-up waves. Mixed with a touch of alizarin crimson, it also makes a useful metallic grey.

NATURAL GREEN

A lot of tube greens are quite vivid and vibrant, and require quite a lot of mixing to tame! This paint is great to use for plant life straight from the tube, and with just a touch of another yellow or blue, you'll find it's a great starting point for lots of different natural greens.

NATURAL BROWN

Pre-mixed from the three primary colours – red, blue and yellow – this natural brown is softer than most browns, making it ideal for tree bark, branches and fenceposts.

NATURAL GREEN LIGHT

Bright and vivid, this green is ideal for sunlit tree canopies or fresh new-growth vegetation.

NATURAL SKINTONE DARK

Everyone's complexion is different, but mixing everything from scratch can be time-consuming; particular when working on a number of different figures, such as in a beach scene. This paint also makes a great base for mixing other colours, too.

NATURAL SKINTONE LIGHT

The companion to natural skintone dark, the two can be used in concert for all manner of different shades. You're not just limited to skin, either – it's a good muted orange that looks good in Mediterranean scenes.

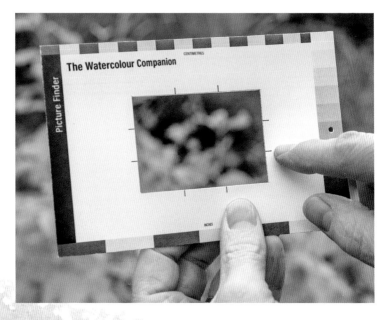

Using the picture finder

This handy tool will help **resolve all sorts of compositional questions and problems** you might have. It pops up throughout the book as I use it to help explain specific topics and solve particular problems. These pages give you an overview of this invaluable tool.

Inside and outside

The picture finder can be useful **both indoors and out** – the colour isolator can be used on location, for example, but it can also be used in the studio to help identify colours from a photograph or your phone screen. Keep it with you and you'll quickly find just how useful it can be!

The window

Hold up the picture finder in front of you and look through the window to cut out visual clutter from around what you want to paint.

The window has two marks on each of its four sides. These are here to help you with a **traditional method of composition**: the Rule of Thirds, explained on page 49.

The tone checker

The right-hand side has a bar that ranges in tone from white to black, allowing you to see whether an area is lighter or darker than its surroundings. This will help you **dilute your mixes to the right consistency** (see pages 14–15).

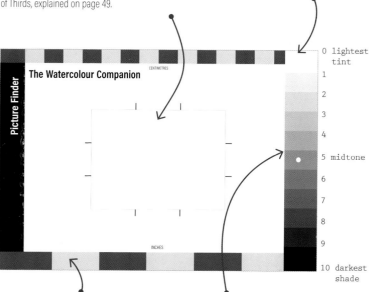

The Watercolour Companion

Picture Finder

CENTIMETRES

INCHES

0 lightest tint
1
2
3
4
5 midtone
6
7
8
9
10 darkest shade

The proportional rulers

These alternating blocks of grey are used for **estimating and comparing distances**. Align the corner of the picture finder with an object such as a tree, or feature like a petal, and you'll quickly be able to see how many 'blocks' away other objects are.

There are two proportional rulers; one in centimetres and the other in inches, but you can happily use them simply as larger or smaller 'blocks', depending on what you need to help compare distances. See pages 86–87 for more information on this.

The colour isolator

Holding this small hole over the object will frame the detail with a neutral midtone that helps to **simplify the area** so you can prepare your paint mix and compare it with this isolated detail for **improved colour accuracy**. You can see how this works on page 55.

Working from photographs

Not all of us have the time to sit and paint a watercolour on location, so a perfect solution is take a photograph and paint it once you are home. As someone who loves photography, I find it a great way of working – and of course these days we usually have a camera in our pockets.

Get into the habit of taking photographs when you see something inspiring. Working from your own photographs gives you the time to think about how to approach your painting and make even the most complex image more approachable. Going from photograph to painting is then as simple as these three steps.

Take the photograph

A camera is a great compositional tool. Using the screen or viewfinder as a framing tool, arrange the image so the sky fills two-thirds and the land (or sea) fills the rest – or vice versa – then take the picture.

You can also just snap away. The great thing about digital photography is that there is no limit on the number of shots we can take. It's often the most instinctive, unplanned shots that make the best paintings.

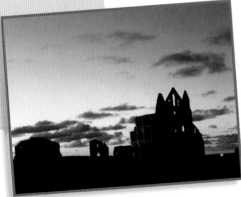

WHAT TO SHOOT?

If you find it tricky to compose your photographs, some cameras will show a grid in the viewfinder that splits the image into thirds for you. See pages 24–25 for how to use the picture finder to help your composition.

Make several sketches to develop the composition

This is where the fun starts! Make a small rough **'thumbnail'** sketch on any old paper. Next, develop it by making several more considered sketches. Each time leave a few bits out, and add a few bits.

A good rule is decide upon a **focal point** (see page 29 for more info) and build around that. Don't be afraid to move or shrink a tree, leave out a few windows or even change the sky in these small preparatory sketches.

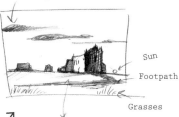

Strong clouds

Sun

Footpath

Grasses

My initial rough thumbnail sketch, which I used to identify the focal point and the main elements I wanted to include.

In this later thumbnail sketch, I developed the foreground, adding the pond in front of the abbey – changed from the footpath in the initial sketch.

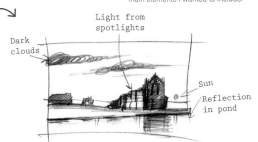

Light from spotlights

Dark clouds

Sun

Reflection in pond

Paint the scene

Once you are happy you have developed the sketch as you wish, transfer the drawing to a larger sheet of watercolour paper and paint away.

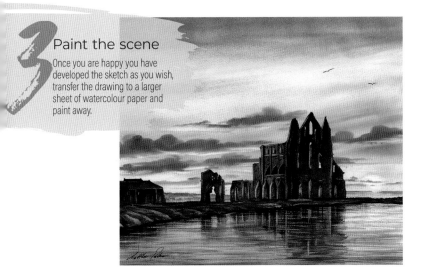

What to paint?

There is no formula for a perfect picture, but these compositional basics will give you some tried-and-tested approaches to ensure that your painting catches – and holds – the viewer's attention. If you haven't worked out what you want to paint, flick through the book and look for something that inspires you.

If, on the other hand, you already know a place that you'd like to paint, try working through the following ideas to make sure you get it in the best possible light:

• **Different points of view** Move around until the scene talks to you. Some scenes may offer two or three great potential pictures, so it's worth walking around and exploring different approaches before settling on one to paint.

• **Different times of day** Even if you stay still, the scene will change before you. Make a virtue of this and sit still while the sun moves overhead. You may find an initially unpromising scene develops into something striking at a particular time of day.

• **A single view** Close or cover one eye. This helps you to focus on how the scene will appear in two dimensions on the painting surface. It is also helpful when using the viewfinder to survey the distant scene.

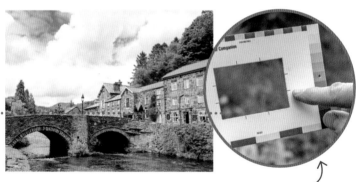

The Rule of Thirds

A good rule of thumb is to arrange the horizon so that the sky fills one-third of the picture, and the landscape fill the remaining two-thirds – or vice versa, with the sky filling two-thirds, in the example above. The dotted line marks the lower third of the painting, showing the top of the bridge just brushing it, and the sky fill the top two-thirds.

HELP FROM THE PICTURE FINDER

The picture finder can help you find these thirds – look for the markings at the edges of the cut-out. Align these with the horizon and you'll find a wealth of options for composition.

Focal points

Focal points turn a pleasant image into one that catches the eye. They act as **anchors for the viewer's eye** to rest upon and come back to.

- Avoid placing focal points at the edges, as the eye will slip out of the painting. Similarly, avoid the dead centre, as it can create a boring, static feel.

- Add more detail to your focal points to give the viewer something to take their time over.

- High contrast in tone draws the eye, so for maximum impact, aim to set light objects against dark backgrounds, or vice versa.

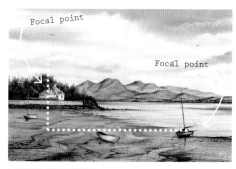

Focal point

Focal point

L-SHAPED COMPOSITION

An L-shaped composition works well to lead the eye around a picture (see the dotted line above). It makes sense, it is simple to understand and works every time. Here, the two main focal points sit on the L, while the other, simpler and less-detailed boats help to guide the eye between the building and main boat.

Note that the white building is set against a dark copse of trees, while the dark boat jumps out against the pale water. Contrast in tone draws the eye.

Finding focal points: the grid

Splitting the scene into three, both horizontally and vertically, will create a grid. The points where the lines of the grid cross give you four potential focal points. **Placing the main subject on one of these points will always make a good composition.**

The example here shows how the grid can be used to help identify potential focal points. Here, the bridge (3) and the buildings (4) sit well and help make a nice composition. Notice the bridge also runs along the line of the bottom third of the image.

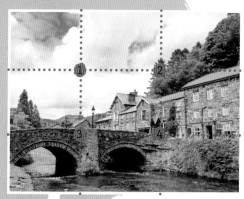

Clear sky

The sky is an important part of almost any painting, and clear skies always give a wonderful sense of open space to a landscape.

Clear skies can be as simple as a flat wash of colour, but it is easy to make them more interesting. A touch of warm pink in a clear blue sky, as in this painting of a French lavender field, helps to evoke the feeling of early evening.

Wet into wet

While the surface of the paper is wet, any paint you apply will drift on the wet surface and give a smooth, brushstroke-free result. Wet the paper with clean water and allow it to sink into the surface for a few moments before you begin. Once the gloss has gone, you have a few minutes to apply your paint. Stop once the surface starts to dry, or you will spoil the effect.

WET INTO WET
Look for this sheen on your surface. This will tell you when is the right time to apply your paint. The water needs to have penetrated the surface, but not completely sunk in.

SPEED AND BLEED

Use a large (size 20) round brush, carrying plenty of paint with which to work. Work upwards from the horizon, adding the pink. Next, add the blue while the surface is still wet. Start at the top, work down and blend the colours together where they meet.

LEAVE GAPS

Don't feel you have to cover the whole area uniformly. Leave a few white gaps in the sky to give more life and suggest a few soft clouds.

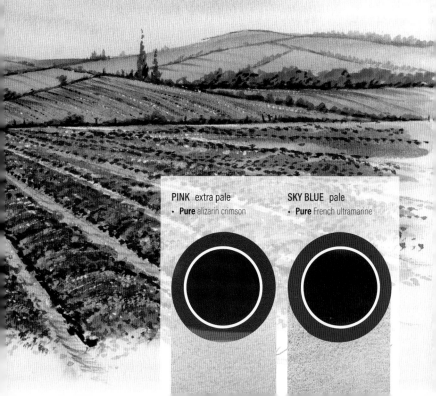

PINK extra pale
· **Pure** alizarin crimson

SKY BLUE pale
· **Pure** French ultramarine

Fresh cloudy sky

Clouds offer a way to add interest and suggest movement in a sky. Use the white of the paper for clean, bright clouds.

The cloudy sky on this lakeland scene was achieved with various techniques, from dabbing off clouds while the sky was wet, to adding grey shadows after the sky had dried.

DABBING OFF

Dabbing off while wet

Start out with a wet-into-wet sky (see page 30), leaving loose white shapes for the clouds. While wet, quickly 'scrunch up' a little kitchen roll and dab the surface to lift away convincing clouds. If the paper is too dry, this effect won't work. Practice is the key.

Dabbing off gives soft, loosely-controlled results: good for clouds. If you want more control or sharper marks, then lifting out (see page 41) is better suited.

OPAQUE WHITE

Opaque white

If your sky does dry, 'cotton wool' clouds can be added afterwards with an opaque white. Use wet blending (see below) to soften them into the surface.

WET BLENDING

Wet blending

Wet blending lets you add a mark, then draw the colour away so it fades to nothing – perfect for cloud shadows! Paint a random, wandering line where you want the bottom of a cloud to be. Ensure you use quite a pale mix and make a wide line. Next, use a clean, damp brush to draw the wet paint upwards, blending it away.

FORM AND STRUCTURE

Grey shadows add shape to the clouds. Paint these once the sky is dry, using a round size 6 brush. Blend upwards into the cloud to create a smooth transition.

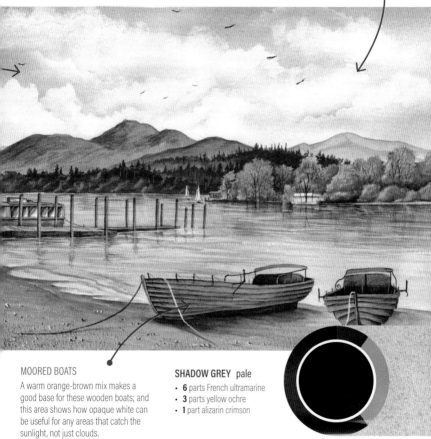

MOORED BOATS

A warm orange-brown mix makes a good base for these wooden boats; and this area shows how opaque white can be useful for any areas that catch the sunlight, not just clouds.

These ropes have been painted over the finished boat with opaque white and a rigger brush – much simpler than leaving a gap.

SHADOW GREY pale

- **6** parts French ultramarine
- **3** parts yellow ochre
- **1** part alizarin crimson

BOAT BROWN pale

- **8** parts burnt sienna
- **2** parts burnt umber

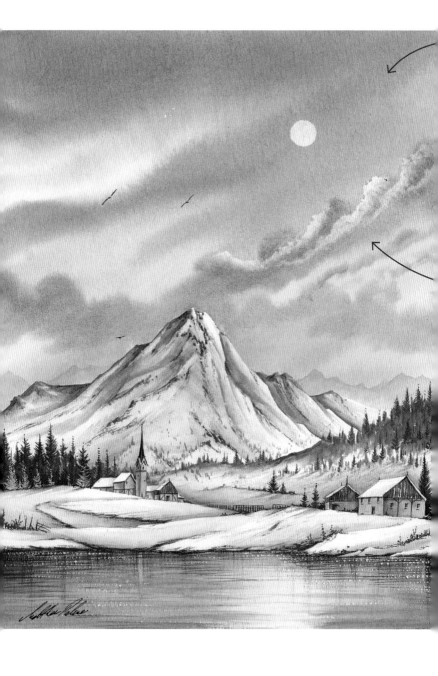

Evening sky

Painted using a size 20 round brush. Add the warm 'flesh tone' near the horizon first, then add the deep violet wet into wet from the top down.

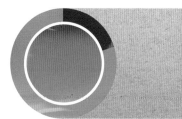

FLESH TONE pale
- **8** parts yellow ochre
- **2** parts alizarin crimson

Twisting

As you apply the paint, twist or roll the brush in your hand. This deposits the paint slightly unevenly, resulting in an interesting travelling mark that is ideal for the base of clouds.

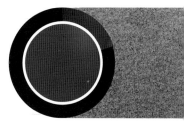

DEEP VIOLET strong
- **8** parts intense or dioaxzine violet
- **2** parts French ultramarine

Evening sky

Not all clouds are white. Evening skies often suit a cloudy atmosphere, especially if we include the sun or moon. In this alpine scene, I have used warm colours for a cloudy evening sky.

Avoid hard edges

Use a clean damp splayed brush to gently agitate the wet paint at the edges of the twisted brushstrokes to soften them away.

Key mixes for SHADOWS

The most important aspect to any painting is shadows: they give depth, life and three-dimensionality. Using these mixes you will be able to create the perfect shades for your paintings. Shadows work particularly well at the corners of paintings, helping to keep the eye in the picture by subtly suggesting a frame.

Blending shadows in

Adding shadows is as simple as mixing a colour suitable for the painting, and using a brush to apply it where you want the shadow to be. Quickly **rinse the brush**, and tap off any excess paint. **While the paint is still wet**, use the clean damp brush to blend the paint away to nothing. For this snow scene, I've used the **cool grey shadow** mix shown opposite.

- Make sure the area is completely dry before you begin
- Aim for a smooth finish.

Natural grey

It's so important to mix the right tone for shadows. Avoid using Payne's gray, lamp black or any watercolour with black pigment, as this will deaden the colour. Instead, when you need a lot of grey, I suggest you use natural grey (see page 22) for speedy and consistent colour mixing.

SHADOW GREY

- **6** parts French ultramarine
- **3** parts yellow ochre
- **1** part alizarin crimson

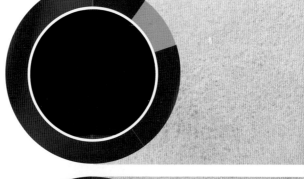

COOL GREY SHADOW

- **8** parts French ultramarine
- **1** part yellow ochre
- **1** part alizarin crimson

WARM GREY SHADOW

- **5** parts French ultramarine
- **4** parts yellow ochre
- **1** part alizarin crimson

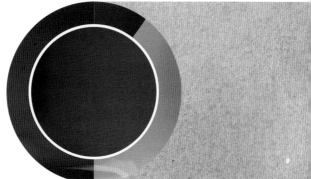

Sunset

Dramatic silhouettes, strong shadows, vibrant skies, and dark clouds.
These are all things that make up wonderful sunsets.

Sunbeams

By agitating the surface gently with a small,
damp, flat brush, you can reactivate the paint.
Next, dab it with clean, dry kitchen paper to lift
out the paint and leave a light area.

Cast shadows

When adding shadows, think of the sun (or
other light source) as a spotlight. Shadows will
always point away from the sun.

Cast shadows are darkest near the object,
and gradually fade away further from it.

SHADOWS AND LIGHT

Light texture can be created by using a craft
knife and scratching along the paper, using
the point to scrape off the painted surface and
reveal white marks.

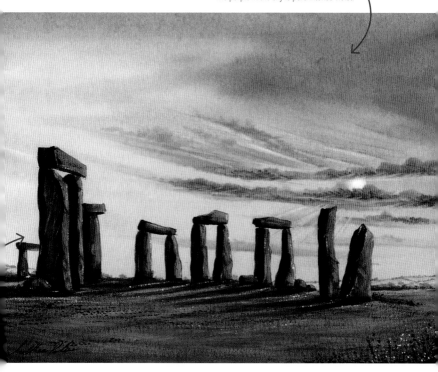

NIGHT FALLING
The purple in the sky is pure intense violet.

DEEP ORANGE strong
- **6** parts cadmium lemon
- **4** parts alizarin crimson

SHADOW GREY strong
- **6** parts French ultramarine
- **3** parts yellow ochre
- **1** part alizarin crimson

DARK GREEN extra strong
- **6** parts French ultramarine
- **3** parts cadmium yellow
- **1** part alizarin crimson

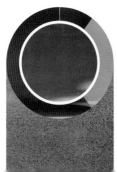

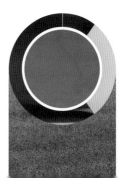

Silhouettes

Adding any type of foreground interest to a painting adds depth, drama and impact. There is no better example to demonstrate this than a vivid sunset with silhouetted foreground.

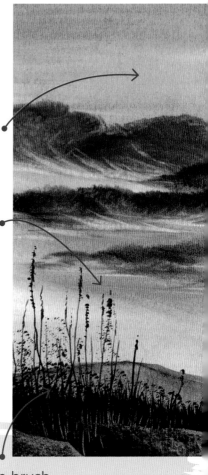

PAINT FROM BACK TO FRONT
Start with the sky and background hills – once they are in place we can add the strong silhouetted detail.

Tall grasses

Use a size 2 rigger or detail brush to paint the long, tall grasses randomly growing out of the mass of short grasses. In this painting, it works especially well on the left-hand side as it balances out the tree on the right. Add in a group of spots at the top of these tall grasses to give the impression of rye grass.

The fan brush

The hairs of fan brushes splay outwards. Originally created to help with blending oil paints (because they help to give a very light touch), they're perfect for grasses. Load the tips of the brush with a very strong shadow grey, place it on the surface where you want the tops of your foreground grasses, then draw it downwards to paint the mass of grass.

Lifting out highlights

Highlights can be added with a 6mm (¼in) flat brush. Clean your brush, tap off the excess water on kitchen paper, then paint with the tip of the brush over the area to be highlighted. Next, dab the area firmly with kitchen paper to lift out the paint and leave a pale highlight.

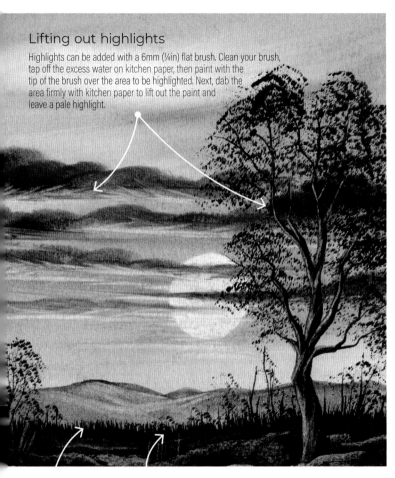

ADVANCING

Using strong dark tones here helps to bring the area forward.

Scratching out

Using the short of edge of a plastic card, gently scrape away some highlighted areas from the dark wet paint. This technique is worth practising and only works when the paint is damp. The stronger the colour, the easier the paint will scrape away with the card. A similar effect can be achieved with the side of a palette knife blade.

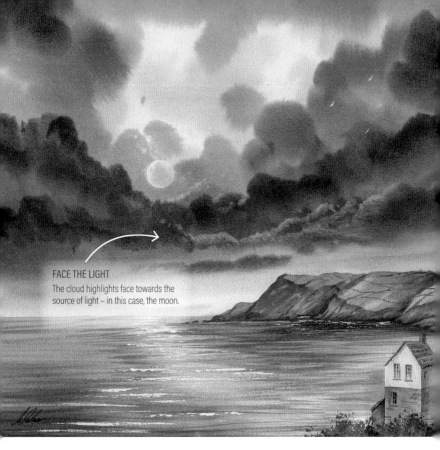

FACE THE LIGHT
The cloud highlights face towards the source of light – in this case, the moon.

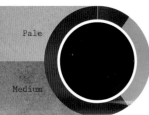

Pale

Medium

Sea and sky

Pure colours give clean results. I've used pale yellow ochre for the sky around the moon, and shadow grey at various strengths for the clouds. The same colours are used in the sea, too.

Note the blue tone in the clouds – this additional interest was created with pale Prussian blue.

SHADOW GREY pale and medium
- **6** parts French ultramarine
- **3** parts yellow ochre
- **1** part alizarin crimson

Moonlit sky

A good dark night sky adds atmosphere to any painting. Adding the moon, with a few highlighted clouds around it, builds even more. In this painting I have added a night sky to this seascape, giving the opportunity to show the moon reflected in the silvery water.

Rolling clouds

Don't be afraid of the dark! Painting clouds in a night sky like that shown here involves curling brushstrokes.

Lay the entire head of a large round brush flat on to the paper and swirl it in place. The bristles create curling, circular marks that are ideal for rolling clouds.

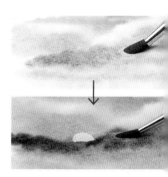

Cloud highlights

The highlights on the clouds are added by rolling up a small piece of kitchen paper and touching the point to the wet paint to lift out light areas. This gives a softer result than using a brush, and still gives you control.

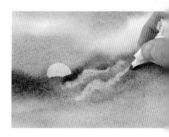

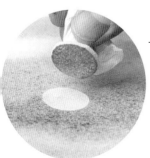

The moon

Double-wrap a coin in kitchen paper and press it into the wet paint. Lift it away and – *voila!* – the moon will appear.

You can develop it with opaque white to one side to give extra light. Blend this away with a damp brush to avoid a hard line.

Stormy sky

Lightning and illuminated clouds in a dark sky look great, and invest any scene with drama. In the painting here, the lightning contrasts nicely with the darkness and balances well with the lighthouse.

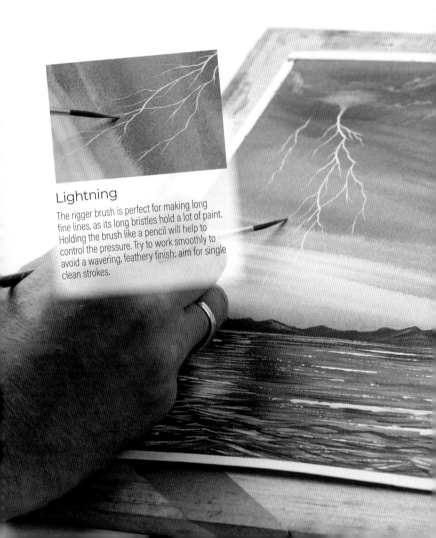

Lightning

The rigger brush is perfect for making long fine lines, as its long bristles hold a lot of paint. Holding the brush like a pencil will help to control the pressure. Try to work smoothly to avoid a wavering, feathery finish: aim for single clean strokes.

Hiding the join

A hard line disappearing into the clouds won't give the effect of lightning: it needs to be softened into the clouds. To attach the lightning to the light areas of sky, work upwards into the cloud, using a damp brush to gently blend the hard white line away.

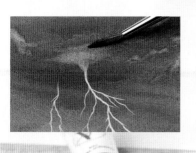

OPAQUE WHITE
Rather than risking getting opaque white mixed in with your watercolours, keep it separate by using a small scrap of spare watercolour paper as a palette.

Rainfall

Rain can be attractive, adding an extra bit of atmosphere to the painting. It's simple to achieve a layered effect, too; relying on a couple of tricks and a little prior knowledge.

Distant rain

Lifting the board after applying pale or extra pale paint will cause the colour to flow downwards. Tipping the board at an angle will encourage the colour to drift diagonally, giving the impression of rainfall in the distance, where individual drops merge into a mass.

- Start applying your paint at the top with horizontal stokes, then lift the board

- Try different angles as you tilt the board in order to create different effects

- Allow the paint to flow naturally – don't use your brush to 'encourage it'.

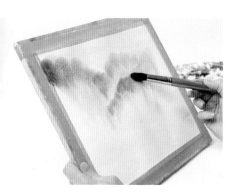

Close-up rain

To achieve the effect of rain falling from clouds, lay a large size 20 brush flat against the paper and twist, moving from left to right. Next, pinch the bristles through your fingers (see inset) to make the brush flat and splay the hairs slightly. Gently drag it horizontally down from the base of the clouds.

- It helps to have less paint on the brush for this technique, so dab your brush on kitchen paper to take off the excess.

- Make sure the rain connects convincingly to the clouds by drawing the paint out of the cloud while it remains wet.

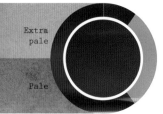

SHADOW GREY pale and extra pale

- **6** parts French ultramarine
- **3** parts yellow ochre
- **1** part alizarin crimson

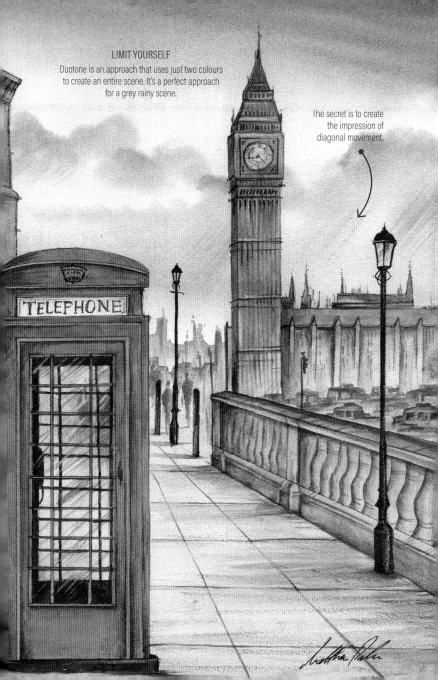

LIMIT YOURSELF

Duotone is an approach that uses just two colours to create an entire scene. It's a perfect approach for a grey rainy scene.

The secret is to create the impression of diagonal movement.

TELEPHONE

Masses of flowers

Masses of flowers are beautiful to look at, and can make great paintings, but they can be complicated. How do you decide which flowers to include? The picture finder offers you lots of options to clear out the clutter and find a striking composition.

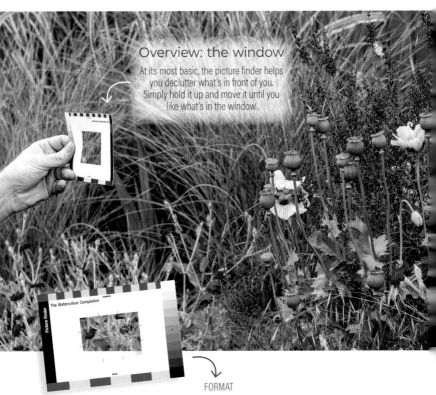

Overview: the window

At its most basic, the picture finder helps you declutter what's in front of you. Simply hold it up and move it until you like what's in the window.

FORMAT

Experiment by turning the picture finder so the window shows a landscape format (wider than it is tall), or a portrait format (taller than it is wide) picture space.

The Rule of Thirds

Imagine lines between the marks on the picture finder window to break the picture space into three parts. You can split the image either horizontally, vertically or both (as pictured below), then move the picture finder so particular flowers or stems align with the lines. It's a reliable way to create a visually balanced scene.

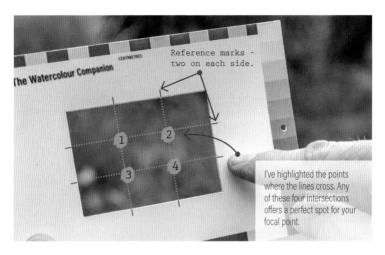

Reference marks –
two on each side.

The Watercolour Companion

CENTIMETRES

I've highlighted the points where the lines cross. Any of these four intersections offers a perfect spot for your focal point.

Here, the lines don't align with anything in particular, and the large flowerhead is near the centre – this makes for a dull composition.

By moving in a little closer, I've lined the stems up with the vertical lines and ensured the large flowerhead sits on the lower-right focal point – this will make a better picture.

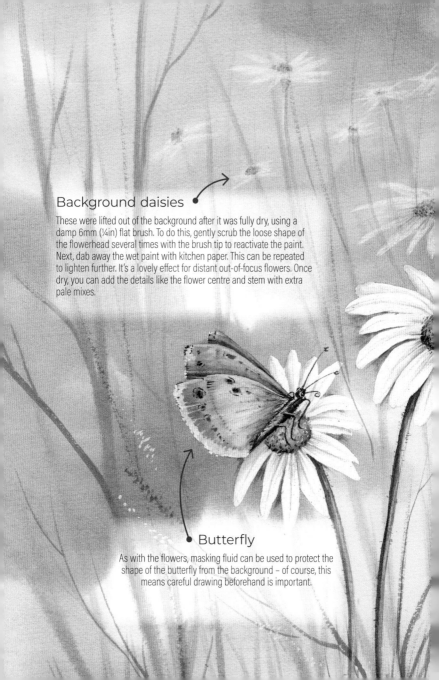

Background daisies

These were lifted out of the background after it was fully dry, using a damp 6mm (¼in) flat brush. To do this, gently scrub the loose shape of the flowerhead several times with the brush tip to reactivate the paint. Next, dab away the wet paint with kitchen paper. This can be repeated to lighten further. It's a lovely effect for distant out-of-focus flowers. Once dry, you can add the details like the flower centre and stem with extra pale mixes.

Butterfly

As with the flowers, masking fluid can be used to protect the shape of the butterfly from the background – of course, this means careful drawing beforehand is important.

White flowers

The crisp white of these daisies is the white of the paper. Masking fluid was applied to protect the area before the background was painted. Once the background had dried, I carefully rubbed away the masking fluid to leave a crisp white shape.

Next, pale shadows were added to separate each petal. These were painted with a small brush and blended away with water to give a smooth graduation from shadow to the white.

The pale orange was added afterwards, over the grey, while the flower centres are a heavier mix of orange – these are simply lots of little spots of paint.

Daisies

Painting landscapes usually suggests a grand vista, but there's no reason you might not prefer something a little more close-up and intimate. Details of common flowers can make for lovely paintings – and the humble daisy is a surprisingly rewarding challenge.

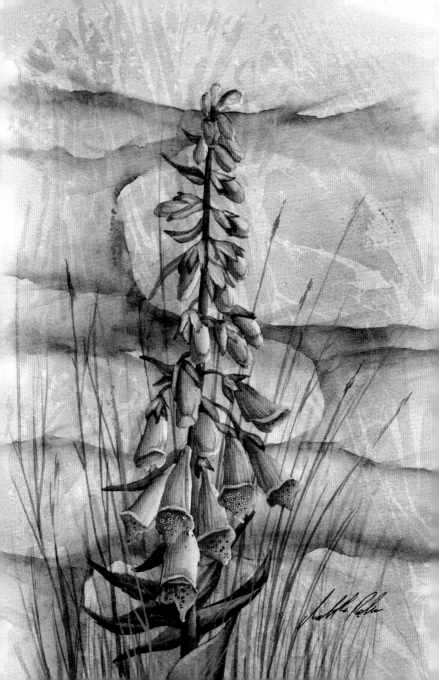

Foxgloves

As with many flowers, capturing the purity of the foxglove's hue requires simple mixes – or none at all. Avoid combining too many paints in your mixes for flowers, as the subtle impurities add up, making the colours muddy or muted.

Foxgloves are beautiful wildflowers, and rose madder is a close match to their natural hue, which frees you up to concentrate on getting the strength and consistency right.

FOXGLOVE medium
- **Pure** rose madder

The curve of a flower

Add the foxglove mix to the shaded side of the flower with strokes back and forth down the height of the flower– in this case, the left-hand side. Rinse your brush, tap off any drips of water and use the damp brush to repeat the back-and-forth movements across the side in the light. This will gently draw out the colour, blending it away to light.

FOXGLOVE SHADOW medium
- **8** parts rose madder
- **2** parts French ultramarine

Foxglove detail

Detail the foxglove only when it has dried. Apply the foxglove shadow mix around the 'lip' and inside, then use the same mix to add small dots. Allow to dry, then paint around them with opaque white.

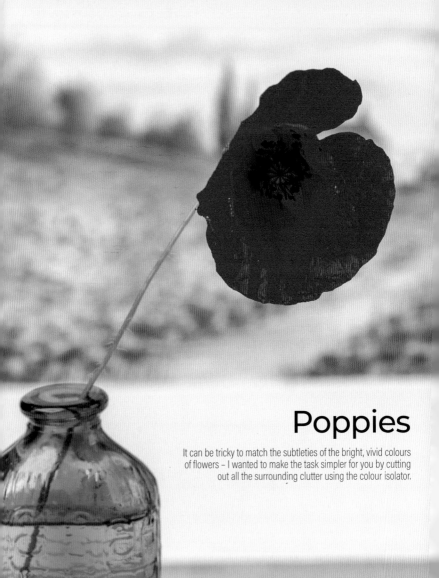

Poppies

It can be tricky to match the subtleties of the bright, vivid colours of flowers – I wanted to make the task simpler for you by cutting out all the surrounding clutter using the colour isolator.

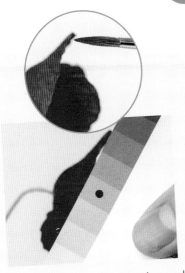

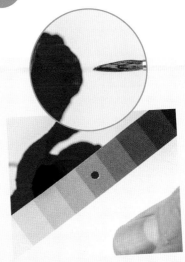

Identifying hue with the colour isolator

The colour isolator in your picture finder is great for vivid flowers like this poppy, where the variation in colour is extremely small. This is because the petals are semi-transparent and allow light through, so there are few clear changes in tone. As a result, it can be tricky to see the subtle differences.

Holding the small hole over the petals will frame the detail with a neutral tone. You can then prepare your paint mix and compare it with this isolated detail for improved accuracy. Because the hole is so tiny, there's no risk of being influenced by the surrounding colour.

Try it on the poppy opposite and see how it helps you to find the subtle differences between the areas in the light and the areas in shadow.

POPPY medium
- **8** parts cadmium red
- **2** parts alizarin crimson

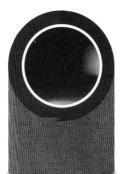

POPPY SHADOW medium
- **6** parts cadmium red
- **2** parts alizarin crimson
- **2** parts French ultramarine

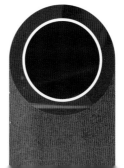

Carpet of bluebells

The strong violets of bluebells make any scene come alive. They can turn a good springtime painting into a great one.

To achieve the effect of a carpet of bluebells across a woodland floor, use the techniques here in concert. A variegated wash across the whole area will create a sense of delicacy and softness in the distance, while stippling in the foreground will add detail and help to create a sense of distance.

Variegated wash

To create an interesting and varied backdrop, you can add different colours to a wash. Working wet in wet with paints of a pale consistency, you'll quickly create an area with distinct areas of colour that flow smoothly into one another.

- This versatile technique can be used with any colours.
- The wetter the surface, the more the colours will mix.

Light on dark

You can build up light texture on a dry dark wash with a stippling technique: tapping the end of a splayed size 6 round brush lightly on the surface to make small marks.

- A specialized Tree & Texture brush (pictured) is ideal for this technique.
- Use an extra strong or strong mix followed by an opaque white mixed with a touch of the violet.

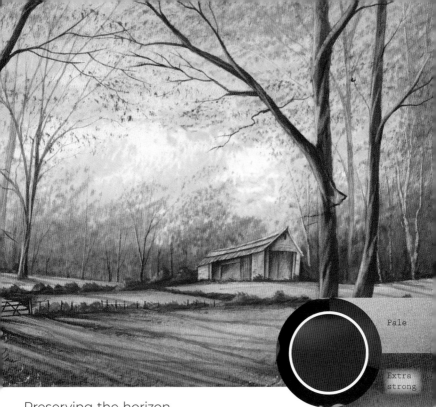

Preserving the horizon

Running a line of masking tape along the horizon before you start to paint will help you to keep the sky and background clean while you paint the forest floor.

- An uneven line adds character.
- To remove the tape once you've finished painting, use a hair dryer to loosen the adhesive, then peel it away slowly.

BLUEBELL VIOLET
pale and extra strong

- **7** parts dioxazine violet
- **3** parts French ultramarine

BRIGHT SPRING GREEN
extra strong

- **8** parts lemon yellow
- **2** parts French ultramarine

Trees in your paintings

Knowing how – and where – to include trees in your composition can be difficult. Here are some tips and ideas for compositions including trees. If you're making up your own scene, the first thing to say is that it's important that your trees are appropriate – oaks on the beach or sun-kissed palms in a snowy Northern field won't give a convincingly realistic result!

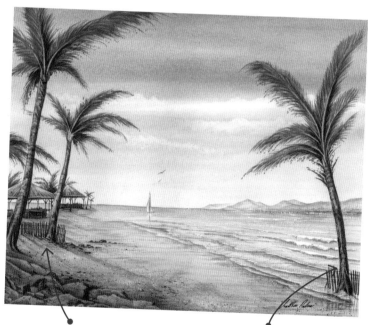

Unbalance things

Pairs of objects – particularly dominant ones like trees – can make a scene feel static and dull. Odd numbers create a slight unbalancing effect that encourages the viewer's eye to roam and enjoy.

Framing

When they're not the focal feature, consider including trees at the edges of your paintings. They create a visual frame, keeping the viewer's eye from drifting out of the scene.

Leave gaps in the sky

The sky is an important part of any landscape involving trees. Don't feel you have to cover the whole area uniformly – leave a few white gaps in the sky to give more life and suggest a few soft clouds. This will ensure the sky and trees complement one another, which is particularly important for creating interest in winter scenes like these, where the foliage is largely absent.

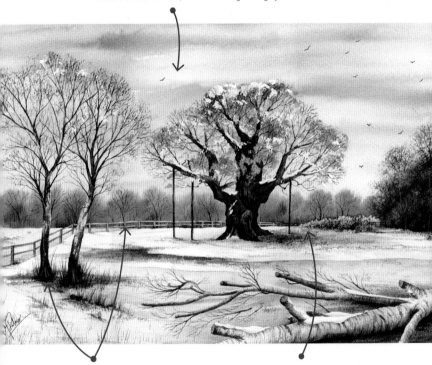

Variety

Including trees on just one plane – that is, in the foreground, midground or background alone – can look odd. Unless you are trying to create a particular effect, try to include both more distant and close-up trees; and perhaps different species of trees, too. Practise the techniques you need for each.

Adding character

These strange-looking vertical posts are supports for this famous tree: the Major Oak, said to be the shelter and hide-out of the folk hero Robin Hood and his Merry Men. Unusual features like this make ideal focal points for a painting.

Midground trees

Trees are a staple in landscapes, adding height and interest to your compositions.

Stippling the foliage

Holding the brush upright, tap the tip repeatedly in the palette as you collect the paint; this will 'break open' the bristles and split the point. You then repeat the tapping motion with the brush on the paper.

- Use a size 6 round brush for smaller trees or a size 10 for larger trees.
- The size 10 will give larger and wider-apart leaves – great for closer foliage.

Fine branches

Lighter, fine branches can be added while the first wash of green paint is still damp. Use a small metal palette knife to scrape them away.

- This great effect only works if the area is still damp.

Adding shadows

As with everything in a painting, shadows are key to making the subject look realistic. Use a strong shadow green and stippling to create shadows in foliage.

- Add areas of shadow within the foliage in almost horizontal sections.
- Use a size 6 brush to paint the trunk and a size 1 or 2 rigger for fine branches.

Tips for branches and trunks

- Add the trunk and branches after you have painted the foliage on summer trees. There tends to be more green on show than branches.
- Successful branches are painted in the direction they grow.
- Dab off excess paint using kitchen paper before painting.
- Hold the rigger like a pencil and rest your hand on the paper.

STIPPLING

Most mid-distance trees appear as a solid central mass of foliage that thins out and opens up towards the outside. This is achieved by adding more stipples to the centre and easing the stipples as we work away to the edges.

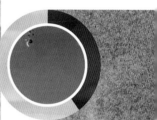

BRIGHT GREEN medium

- **8** parts cadmium yellow
- **2** parts French ultramarine

GREEN SHADOW medium

- **6** parts cadmium yellow
- **3** parts French ultramarine
- **1** part alizarin crimson

RICH DARK strong

- **8** parts burnt umber
- **2** parts French ultramarine

SHADOWS AND CONTRAST

Where your tree meets another object, like this building, build up the shadow next to it. This will give great contrast and make the tree sit back and the object pop forward.

Key mixes for
SPRING FOLIAGE

Spring foliage is generally made up of bright, fresh greens that lean more on the yellow paints in your palette than the blues.

Here are three that I regard as essential. Introducing lemon yellow will give more vibrant results than cadmium yellow.

BRIGHT SPRING GREEN

- **8** parts lemon yellow
- **2** parts French ultramarine

MID SPRING GREEN

- **6** parts lemon yellow
- **4** parts French ultramarine

SPRING GREEN SHADOW

- **5** parts lemon yellow
- **4** parts French ultramarine
- **1** part alizarin crimson

Cherry blossom

This beautiful early summer display makes a great focal point to a painting. This lesson is great for learning how to add depth to trees and weave branches in between masses of flowers.

Blossom

The secret here is allowing the soft pink of the blossom to merge with the background sky. Have pure rose madder at a pale consistency ready as you paint the sky. While the sky is still wet, use a size 10 round brush to paint the loose shape of the tree, allowing the paint to bleed and spread.

Spotting light and dark

Use the tip of the brush to build up colour in stages with lots of little dots. Using a size 6 round brush and the same pale pink as the soft base, spot away!

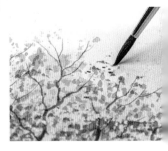

- A great technique for flowering trees: build up midtones and shadows just where you want them.

- Work both within and outside the initial pink wash.

- Mix an opaque white with a touch of rose madder to give some bright blossom.

Branchweaving

Use brown to paint the trunk and branches, skipping some light areas, and overlapping some shadow areas to create a lovely sense of depth.

Taper the trunk, starting with a size 6 brush and moving to a fine rigger brush for the fine branches. Use dark grey to the left of the trunk to give shadows.

BROWN extra strong
- **5** parts yellow ochre
- **4** parts alizarin crimson
- **1** part French ultramarine

DARK GREY extra strong
- **6** parts French ultramarine
- **3** parts yellow ochre
- **1** part alizarin crimson

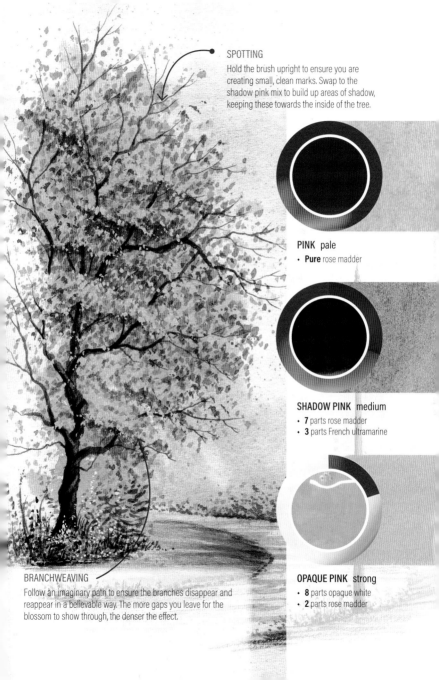

SPOTTING

Hold the brush upright to ensure you are creating small, clean marks. Swap to the shadow pink mix to build up areas of shadow, keeping these towards the inside of the tree.

PINK pale
- **Pure** rose madder

SHADOW PINK medium
- **7** parts rose madder
- **3** parts French ultramarine

OPAQUE PINK strong
- **8** parts opaque white
- **2** parts rose madder

BRANCHWEAVING

Follow an imaginary path to ensure the branches disappear and reappear in a believable way. The more gaps you leave for the blossom to show through, the denser the effect.

Distant woodland

Painting a scene with distant trees is wonderful to give depth to a composition. You have to plan for them, as the background is best put in early one, when you add the sky. This makes it easy to blend things together smoothly.

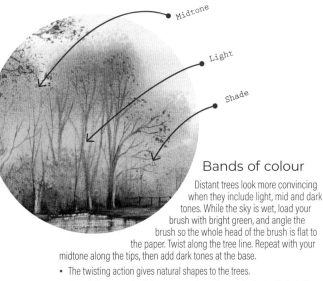

Midtone

Light

Shade

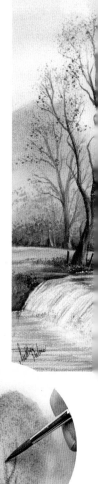

Bands of colour

Distant trees look more convincing when they include light, mid and dark tones. While the sky is wet, load your brush with bright green, and angle the brush so the whole head of the brush is flat to the paper. Twist along the tree line. Repeat with your midtone along the tips, then add dark tones at the base.

- The twisting action gives natural shapes to the trees.
- You might expect the lightest tone to be at the top, in the sunlight. In fact, using the midtone at the top helps to provide definition against the sky, while the light centre suggests sunlight through leaves.
- You can alter the height of the trees to suit the scene when painting the midtone on first. Varied heights look best.

Soft focus

The secret to adding depth to trees is to paint the foliage while the sky area is still wet, so the paint bleeds slightly into the sky: this gives a slightly out-of-focus feeling. Similarly, the trunks look best added when the foliage is not quite dry – the trunks and branches soften away.

Stippling to blend

Using a size 6 round brush (or a specialized Tree & Texture brush, shown on page 56), and the bright summer green, add a few stipples to the tips of the trees and a few areas over the tops of the trees. This helps to blend the three tones of green together.

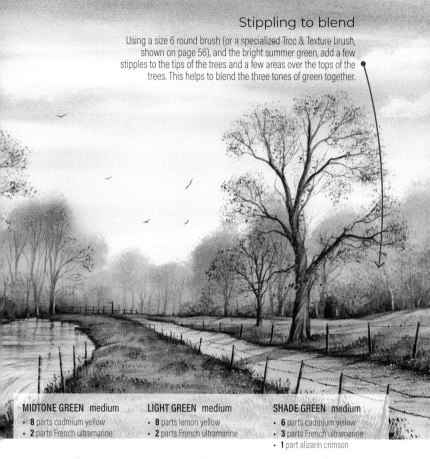

MIDTONE GREEN medium
- **8** parts cadmium yellow
- **2** parts French ultramarine

LIGHT GREEN medium
- **8** parts lemon yellow
- **2** parts French ultramarine

SHADE GREEN medium
- **6** parts cadmium yellow
- **3** parts French ultramarine
- **1** part alizarin crimson

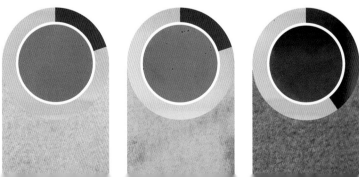

Key mixes for
SUMMER FOLIAGE

As we move into summer from spring, the greens around us tend to become slightly darker. Using more blue in the colour mixes will give you the perfect greens for all manner of summer scenes.

 Using a transparent yellow like cadmium yellow results in less saturation in the green tones, giving wonderful subtlety to your results.

BRIGHT SUMMER GREEN
- **8** parts cadmium yellow
- **2** parts French ultramarine

MID SUMMER GREEN
- **6** parts cadmium yellow
- **4** parts French ultramarine

SUMMER GREEN SHADOW
- **5** parts cadmium yellow
- **4** parts French ultramarine
- **1** part alizarin crimson

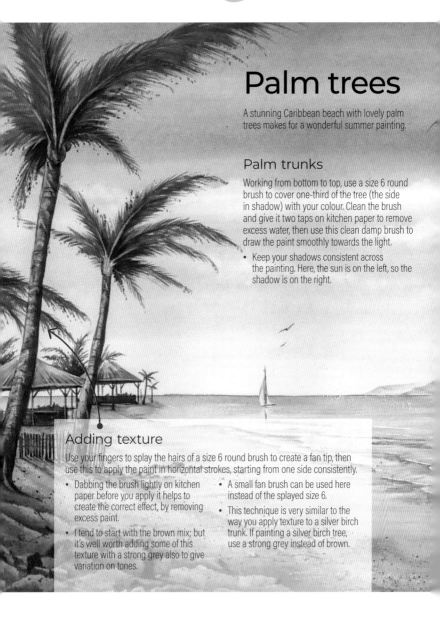

Palm trees

A stunning Caribbean beach with lovely palm trees makes for a wonderful summer painting.

Palm trunks

Working from bottom to top, use a size 6 round brush to cover one-third of the tree (the side in shadow) with your colour. Clean the brush and give it two taps on kitchen paper to remove excess water, then use this clean damp brush to draw the paint smoothly towards the light.

- Keep your shadows consistent across the painting. Here, the sun is on the left, so the shadow is on the right.

Adding texture

Use your fingers to splay the hairs of a size 6 round brush to create a fan tip, then use this to apply the paint in horizontal strokes, starting from one side consistently.

- Dabbing the brush lightly on kitchen paper before you apply it helps to create the correct effect, by removing excess paint.

- I tend to start with the brown mix; but it's well worth adding some of this texture with a strong grey also to give variation on tones.

- A small fan brush can be used here instead of the splayed size 6.

- This technique is very similar to the way you apply texture to a silver birch trunk. If painting a silver birch tree, use a strong grey instead of brown.

Fronds

Start by painting the central spine of each frond with a size 6 round brush. Swap to a small fan brush and use light pressure to work outwards, completing one side at a time.

- Adding a few spots to the tips with a size 6 round brush adds extra life.
- Pay attention to how the palm fronds emerge from the top of the trunk.

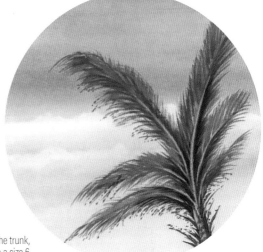

Shadows and highlights

From the point where the fronds meet the trunk, add some dark grey to attach them. Use a size 6 round brush here and work slightly dry with the paint. Use a damp 6mm (¼in) flat brush to lift out the lined highlights on the underneath of the fronds. These stem from the top of the trunk and taper into the fronds. Dab off the highlights with kitchen paper.

MID SUMMER GREEN
extra strong

- **6** parts cadmium yellow
- **4** parts French ultramarine

BROWN extra strong

- **5** parts yellow ochre
- **4** parts alizarin crimson
- **1** part French ultramarine

DARK GREY extra strong

- **6** parts French ultramarine
- **3** parts yellow ochre
- **1** part alizarin crimson

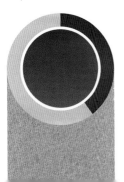
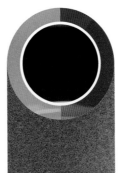
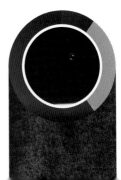

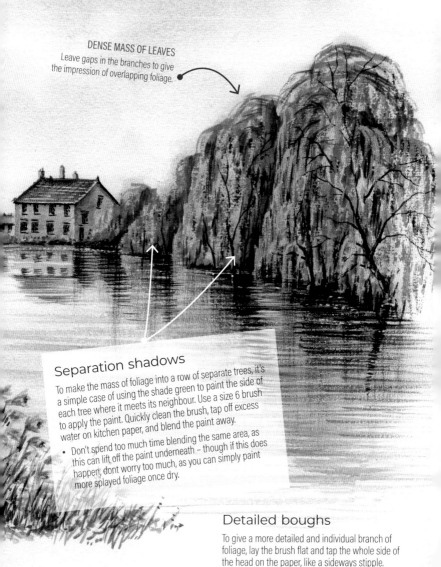

DENSE MASS OF LEAVES
Leave gaps in the branches to give the impression of overlapping foliage.

Separation shadows

To make the mass of foliage into a row of separate trees, it's a simple case of using the shade green to paint the side of each tree where it meets its neighbour. Use a size 6 brush to apply the paint. Quickly clean the brush, tap off excess water on kitchen paper, and blend the paint away.

- Don't spend too much time blending the same area, as this can lift off the paint underneath – though if this does happen, dont worry too much, as you can simply paint more splayed foliage once dry.

Detailed boughs

To give a more detailed and individual branch of foliage, lay the brush flat and tap the whole side of the head on the paper, like a sideways stipple.

Trees in rows

If you have several trees in a row, you can break up the mass of foliage and suggest individual trees by adding separation shadows.

Willows

Willows are the perfect trees to demonstrate separation shadows, as you see very little of the trunks and branches of a willow when their leaves are out in the summer. Shading their dense foliage offers you the best chance of separating them visually. The key technique for these lovely trees is to paint lots and lots of drooping lines that curve down from the top of the tree.

Dry brush

The dry brush technique is the key here. This involves using a size 6 round brush and the green tones shown to the right. Pick up the paint on the brush and gently tap off a touch on some kitchen paper. Using the splayed tip (see below), paint the dry brushstrokes, curving down from the top and drooping towards the water's edge. Repeating this will build up the willow tree texture.

Alternate between the silver green and shade green, adding only a few areas of the opaque green. Use the shade green once dry for the separation shadows. As a finishing touch, use the dry brush technique with the opaque green to overlap the shade green and give a three-dimensional effect to the canopy.

SPLAYING THE BRISTLES

Use your fingers to pinch the hairs of a round brush and splay them open in a fan shape as shown to the left. You can use this like a traditional fan brush to produce lots of parallel lines: perfect for willows.

SILVER GREEN medium
- **6** parts viridian hue
- **4** parts cadmium yellow

OPAQUE GREEN medium
- **3** parts cadmium yellow
- **2** parts French ultramarine
- **5** parts opaque white

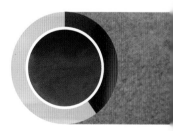

SHADE GREEN medium
- **6** parts cadmium yellow
- **3** parts French ultramarine
- **1** part alizarin crimson

Key mixes for AUTUMN FOLIAGE

My favourite season – autumn is great for colourful landscapes and woodlands. Not all trees change colour at the same time, so these rich, warm brown and gold mixes can be used in concert with the spring and summer greens on pages 63 and 69.

BRIGHT AUTUMN BROWN

- **8** parts cadmium yellow
- **2** parts burnt sienna

MID AUTUMN BROWN

- **6** parts cadmium yellow
- **4** parts burnt sienna

AUTUMN SHADOW

- **5** parts burnt sienna
- **4** parts cadmium yellow
- **1** part French ultramarine

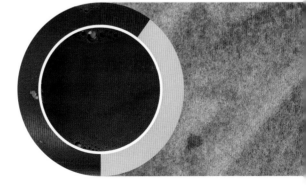

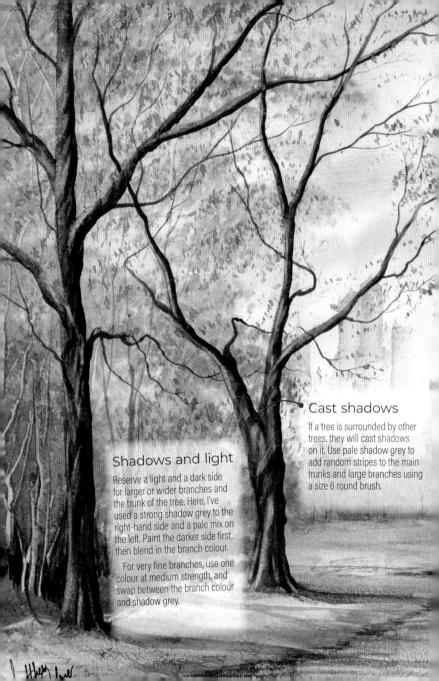

Cast shadows

If a tree is surrounded by other trees, they will cast shadows on it. Use pale shadow grey to add random stripes to the main trunks and large branches using a size 6 round brush.

Shadows and light

Reserve a light and a dark side for larger or wider branches and the trunk of the tree. Here, I've used a strong shadow grey to the right-hand side and a pale mix on the left. Paint the darker side first, then blend in the branch colour.

For very fine branches, use one colour at medium strength, and swap between the branch colour and shadow grey.

Branches

A part of any landscape featuring trees, branches are on show all year. Understanding how trees grow is useful when painting them.

Thick to thin

All tree trunks are wider at the base, and taper off, gradually getting thinner as they split and branch out. A good approach when painting them is to work down your brushes in a similar way.

Start with a large round size 10 brush for the tree base, working upwards in the direction of growth. Gradually lift the brush off the paper, so the point gradually comes together and the line tapers off. When you feel the size 10 is too large, move to a smaller size 6 round brush, again, working in the direction of growth. Finish off with a size 1 or 2 rigger brush for those fine branches.

Branches with a rigger

A rigger is the perfect tool for fine branches, but there is a right and a wrong way to use it. Here are my tips for the best results:

- Hold the brush near the tip, like a pencil, grabbing the metal ferrule.
- Imagine the brush is a pencil as you draw the branches. Practise a tapered flick, easing the brush off the paper as it reaches the end.
- Rest your hand on the paper as you paint. This helps you to control the pressure and paint fine branches.
- Dabbing off the excess paint on kitchen paper helps; the less paint on the brush the finer the detail.
- Paint with just the tip of the brush, not the sides.

BRANCH BROWN medium
- **8** parts burnt umber
- **2** parts French ultramarine

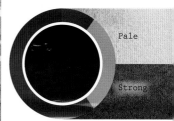

Pale

Strong

SHADOW GREY
pale and strong
- **6** parts French ultramarine
- **3** parts yellow ochre
- **1** part alizarin crimson

Woodland

One of my favourite subjects is painting woodlands in all seasons. The same techniques apply to all seasons – just alter the colours.

One step beyond

Notice how the foreground trees go completely off the top of the painting and the bottoms gently fade into the base – taking trees off the edge of your composition helps create the illusion of size.

Masses of foliage

'Stamping' the surface with an ethically-sourced natural sponge lightly loaded with paint is a perfect way to quickly simulate a random mass of foliage. Wring the sponge out in clean water, dab it into a prepared well of colour, then gently stipple the sponge onto the paper in the area where the foliage would be. Use all sides of the sponge to help give variation to the resulting leaves.

The secret is to experiment. Different sponges will create different patterns. Bending the sponge between your fingers will stretch the sponge and make the marks you make more distant from each other, giving a more sparse effect.

Creating depth

The best way to suggest a woodland is to have the trees receding into the distance. Use more dilute mixes to lighten the tone of the more distant trunks and branches, and add more detail to those in the foreground by using stronger colour and more detail.

Sky, then trees

Paint the background sky – I used pale French ultramarine here – then use a sponge to add the foliage (see opposite) with various mixes at medium strong consistency. I've used greens here, but feel free to try autumnal colours.

Matthew Palmer Lift out Brush - Large

Adding highlights

Use the tip of a damp 6mm (¼in) flat brush to scrub over areas where you want to place highlights, then firmly tap the surface with kitchen paper to remove the colour.

Notice how highlights have been added to the tops of the branches and that these highlights begin from the centres of the main trunk, not just the edges. This helps to suggest the size and form of the tree.

Don't go green

Woodland floors are starved of light, so grass doesn't grow here. As a general rule, keep to grey-brown mixes for the floor.

Buildings in the landscape

For many, the Yorkshire Dales are the quintessential English landscape, with rolling hills and distant trees. But if you want your landscape to include the harder lines of buildings, it's useful to have some way of keeping the hard buildings separate from soft foliage – and that's where masking fluid comes in.

Using masking fluid

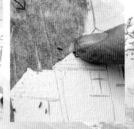

First apply the masking fluid, just like paint.

Allow it to dry, then paint the area – work up to and, if necessary, over the masking fluid.

Once dry, you can gently rub masking fluid away with a clean finger, leaving a sharp, clean edge.

STONE BROWN medium
- **8** parts burnt umber
- **2** parts French ultramarine

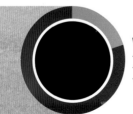

WET-SLATE GREY medium
- **6** parts French ultramarine
- **2** parts yellow ochre
- **2** parts alizarin crimson

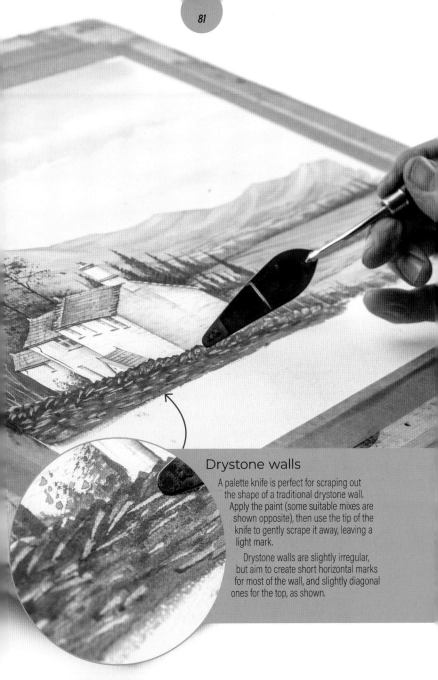

Drystone walls

A palette knife is perfect for scraping out the shape of a traditional drystone wall. Apply the paint (some suitable mixes are shown opposite), then use the tip of the knife to gently scrape it away, leaving a light mark.

Drystone walls are slightly irregular, but aim to create short horizontal marks for most of the wall, and slightly diagonal ones for the top, as shown.

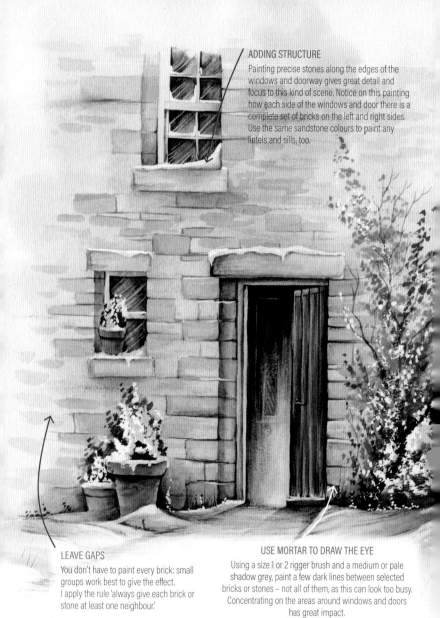

ADDING STRUCTURE

Painting precise stones along the edges of the windows and doorway gives great detail and focus to this kind of scene. Notice on this painting how each side of the windows and door there is a complete set of bricks on the left and right sides. Use the same sandstone colours to paint any lintels and sills, too.

LEAVE GAPS

You don't have to paint every brick: small groups work best to give the effect. I apply the rule 'always give each brick or stone at least one neighbour.'

USE MORTAR TO DRAW THE EYE

Using a size 1 or 2 rigger brush and a medium or pale shadow grey, paint a few dark lines between selected bricks or stones – not all of them, as this can look too busy. Concentrating on the areas around windows and doors has great impact.

Stonework

Whether you want to paint an old cottage, the brickwork of a townhouse or a drystone wall, the techniques are all relatively similar. I find the best approach is to lay in a pale base wash – any of the mixes shown to the right here would work – and then to use a size 6 round brush to paint in the individual horizontal bricks or stones once the background is dry.

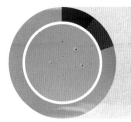

YELLOW SANDSTONE pale

- **8** parts yellow ochre
- **1** part alizarin crimson
- **1** part French ultramarine

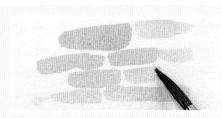

Don't worry about laying perfect bricks. On an old cottage or wall be random and loose. Pick and mix between the red and yellow sandstone colours, and add the occasional pale grey stone.

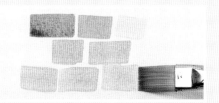

Using a 12mm (½in) flat brush will give more regimental bricks, good for more modern red-brick buildings.

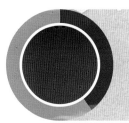

RED SANDSTONE pale

- **6** parts yellow ochre
- **3** parts alizarin crimson
- **1** part French ultramarine

THE SECRET to adding mortar is to use the tip of the rigger brush with only a little paint on the brush. Tap off excess paint on kitchen paper – the less paint on the brush, the finer the line you can paint. As each dark line tapers off – achieved by gently lifting the brush away as shown – the stones will settle further into the scene.

Holding the brush like a pencil, right on the metal ferrule, helps; as will resting your hand on the paper.

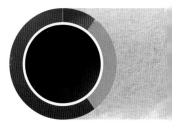

SHADOW GREY pale

- **6** parts French ultramarine
- **3** parts yellow ochre
- **1** part alizarin crimson

Doorways

Paint what catches your eye. If you like a doorway or other detail, you don't have to give yourself extra work by painting the whole building – just fill your paper with a little detail and fade it away to nothing at the edges.

Fading the colour away to nothing at the edges of a painting like this is called a vignette. It's a trick that works well on doorways and window paintings and makes very pleasing watercolours, especially with flowers.

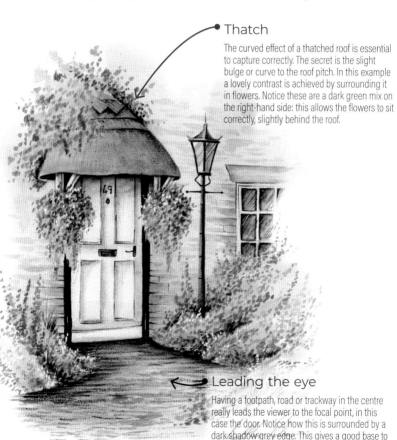

Thatch

The curved effect of a thatched roof is essential to capture correctly. The secret is the slight bulge or curve to the roof pitch. In this example a lovely contrast is achieved by surrounding it in flowers. Notice these are a dark green mix on the right-hand side: this allows the flowers to sit correctly, slightly behind the roof.

Leading the eye

Having a footpath, road or trackway in the centre really leads the viewer to the focal point, in this case the door. Notice how this is surrounded by a dark shadow grey edge. This gives a good base to the flower beds. A dry brush was used to add the shadows here, dragging horizontal lines from the edges to the centre of the path.

Wisteria

As you can see from these two examples, I love painting small spotty flowers like wisteria – and that's all they are: hundreds of spots. Use different strengths of your base mix (the colour will depend on the type of flower) to paint the dots. Once dry, mix an opaque white with the base colour. This will give you an opaque, lighter tone of the colour, allowing you to overpaint the flowers for even more depth.

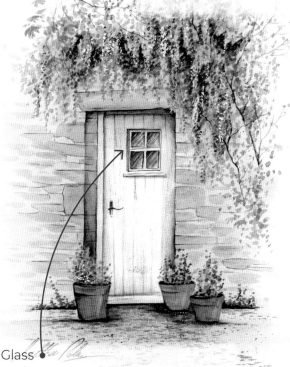

Glass

The windows here give the impression you can see through them. The secret is depth! Using a small brush and a strong shadow mix (see page 37 for some options), divide the window into two diagonal halves. Paint the upper left-hand half solid grey and blend to the right using a damp brush, being careful not to go outside of the window pane. Once dry, use a craft knife to scratch off some diagonal light reflections.

Architectural accuracy

The proportional rulers on the picture finder are particularly useful for helping with pictures of buildings, where accurate estimation will help you place features correctly.

The two examples here give some ideas of how you can use the rulers for measurement and comparison, but it's just the tip of the iceberg. You might also use the picture finder as a handy straight edge when sketching out buildings.

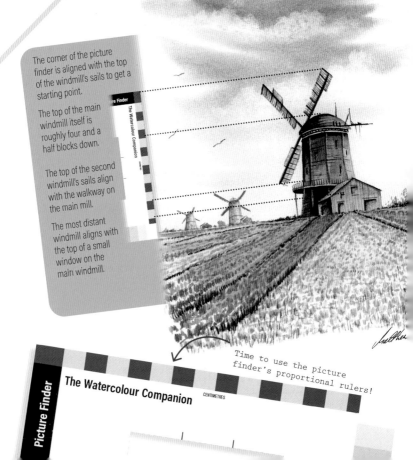

The corner of the picture finder is aligned with the top of the windmill's sails to get a starting point.

The top of the main windmill itself is roughly four and a half blocks down.

The top of the second windmill's sails align with the walkway on the main mill.

The most distant windmill aligns with the top of a small window on the main windmill.

Time to use the picture finder's proportional rulers!

The Watercolour Companion CENTIMETRES

Picture Finder

NEGATIVE SPACE

One of the most useful ways to use the proportional rulers is to help work out how much 'negative space' you need to leave. It's easy to over-focus on complex architectural features like windows and ignore or underestimate how much space you have between them. Here you can see that the space between the windows is equal in width to the left-hand window itself.

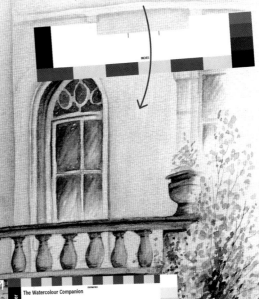

The Watercolour Companion

REGULAR FEATURES

Great for patterns and repeated shapes like this balustrade, the proportional rulers will help you get the basics like spacing and height right, so you can concentrate on the shapes.

Rocks and cliffs

I love painting cliffs and rocks, especially by the sea. You can use a palette knife or plastic card to create the texture of any craggy subject – the technique is so simple that it seems like magic!

The paper you use makes a difference. Rough or Not surface papers work best for scraping, as they have a pronounced texture.

Card scraping

Working over wet paint, place the short side of a plastic card onto the surface where you want your cliff to finish. Putting gentle pressure towards the corner of the card, move the card to scrape the paint away, following the direction or contour of the cliffs. Very little pressure is needed.

The scraping action removes the paint from the surface while leaving it in the recesses, resulting in a wonderful light texture.

Stay wet

Dry paint can't be removed. If your paint is drying, don't press harder to try to scape it away – you'll damage the surface. Instead, allow it to dry, then use a damp brush to glaze water over the entire area to reactivate it, and try again.

Be strong

Strong mixes are the key. The stronger the paint, the easier it is removed with the card/knife. Don't worry about the initial darkness of the colours – much of the paint is scraped away, and you need that contrast of tone to suggest the rugged texture of the stone.

STONE BROWN strong
- **8** parts burnt umber
- **2** parts French ultramarine

Distant cliffs

Keep the colours pale to create depth. Decide where the light is coming from and, using a size 6 brush, add a medium grey to the dark side, followed by a pale grey to the left.

The palette knife/plastic card technique won't work here as the paint needs to be strong. Instead, use a 6mm (¼in) flat brush to lift out highlights once dry.

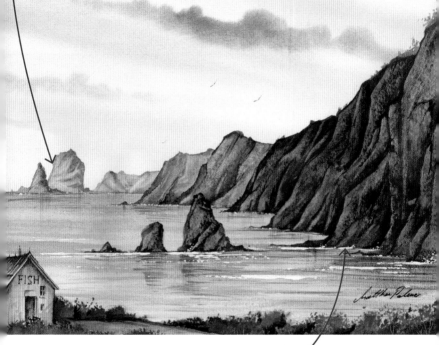

Developing scraped marks

To add subtlety and give you more control over the finish, add extra shadows with a size 6 brush next to the scrapes. These can be blended away from the light, scraped line using a damp brush.

This give great separation and depth. Consider using a size 1 or 2 rigger brush to paint a few additional cracks and detail in the cliffs or rocks for interest, too.

Mountains

Fresh, crisp, alpine scenes make great landscape paintings and are a particularly good place to practise painting high contrast shadows.

Masking tape skylines

You can use masking fluid (see page 80) to ensure a clean break between sky and horizon, but for snow-topped mountains I prefer to use masking tape – it's quicker and gives a great natural effect.

A little paint may creep underneath the edge, but don't worry: it will blend into the shadows on the peaks when you come to paint the mountains.

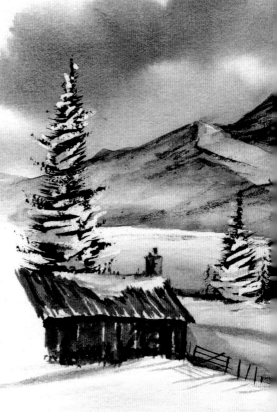

DEEP PURPLE medium
- **6** parts French ultramarine
- **3** parts yellow ochre
- **1** part alizarin crimson

ALPINE SHADOW medium
- **9** parts French ultramarine
- **1** part Prussian blue

Masking tape tips

Before applying the tape, ensure you remove some of the stickiness by rubbing your fingers over it. Crease the tape as you stick it, and follow the contour, making sure you have a tight seal on the top edge, where the sky meets the mountain. The bottom edge is not so important; you can even leave it sticking up a bit, as shown, to help you follow the line of the mountain.

Once in place, you can paint the sky, allow it to dry, then gently peel away the tape to reveal a perfect skyline.

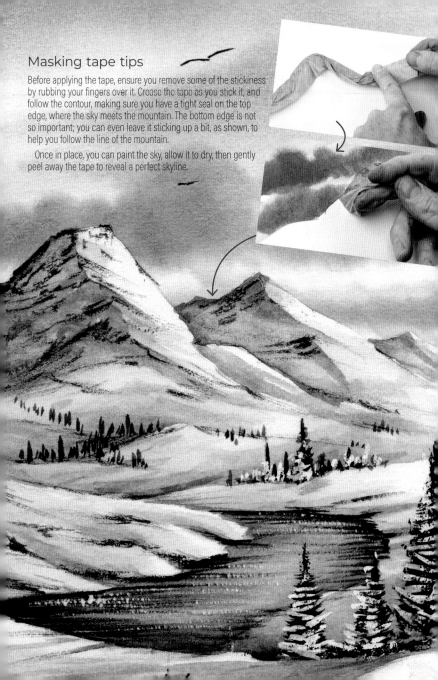

Snow-capped peaks

Snow-capped mountains add great atmosphere to any watercolour. The secret is
to have your colours prepared and wet the snow-covered area of the mountains
using a wet-on-wet technique.

Impact and contrast

Surrounding the peaks with dark
clouds really helps the snow area to
stand forward.

Painting the mountain

Working quickly, paint the top section of the
mountain, allowing the grey paint to bleed and
spread into the snow-covered wet area. Do
the same with the grey-green, working in the
lower section of the mountain. It is important to
slightly overlap the foreground mountain.

Crisp and clean

To create a clean edge where the mountains meet the riverbank,
apply a strip of masking tape before you begin painting. Press
the tape down firmly using your fingernails to give a more
natural character to the edge of the tape.

Creating impact

You'll notice all the mixes used here are strong – that's a
good recipe for a punchy painting with plenty of impact.

MEADOW GREEN strong

- **6** parts cadmium yellow
- **2** parts lemon yellow
- **2** parts French ultramarine

SANDSTONE strong

- **8** parts yellow ochre
- **1** part alizarin crimson
- **1** part French ultramarine

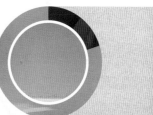

CLOUD PURPLE strong

- **7** parts French ultramarine
- **3** parts alizarin crimson

GREEN-GREY strong

- **5** parts yellow ochre
- **4** parts French ultramarine
- **1** part alizarin crimson

Key mixes for
THE SEA

Here are three mixes that will give you ready-to-go colours for seascapes. The colour of the sea varies a great deal, depending on the time of year, time of day and the conditions: look at what's in front of you for inspiration.

You'll notice a red-based mix here, which is perfect for when the water's surface is reflecting a sunset sky. Using this alongside the other two mixes will help create a warm evening atmosphere.

MEDITERRANEAN SEA

- **6** parts French ultramarine
- **4** parts viridian hue

EVENING SEA

- **6** parts French ultramarine
- **4** parts Prussian blue

SUNSET SEA

- **7** parts cadmium yellow
- **3** parts alizarin crimson

Waves and sea spray

Lapping waves, crashing spray and rivulets of water give wonderful life and movement to any watercolour seascape. These special effects are quick, easy and effective – just make sure that the underlying paint is dry before you start!

I often use opaque white when painting the sea, as it allows me to paint light over dark – so there's no need to worry about reserving the white before painting the sea itself.

Specialist brush for spray

Specialist brushes aren't limited to their obvious use. A Tree & Texture brush is ideal for sea-spray, for example. Load it with dilute white gouache, then tap it lightly on the surface to stipple on your ocean spray.

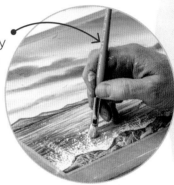

Sparkle

You can't get brighter than the white of the paper, so use a sharp craft knife to carefully scrape horizontal lines from the surface. The revealed white paper makes a convincing highlight.

Rivulets

What goes up, must come down – so any water that splashes onto the rocks will drip down them. Use a rigger brush to add fine, wandering marks with opaque white. Add just a few: less is more.

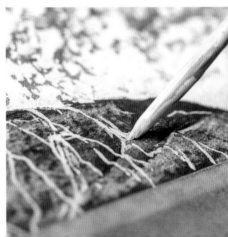

The beach

Who can resist a sunny seaside break? Not me! Beach huts and deckchairs are often bright colours, so you can take the opportunity to use some less-used colours to make them an eye-catching focal point. Equally, you might choose to use colours used elsewhere in your mixes, to give a relaxing, harmonious feel.

SEA TURQUOISE pale
- **8** parts viridian hue
- **2** parts Prussian blue

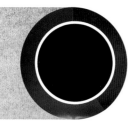

SEA SHADOW pale
- **6** parts viridian hue
- **4** parts French ultramarine

BEACH SAND medium
- **8** parts yellow ochre
- **1** part burnt sienna
- **1** part French ultramarine

WET SAND medium
- **8** parts burnt sienna
- **1** part yellow ochre
- **1** part French ultramarine

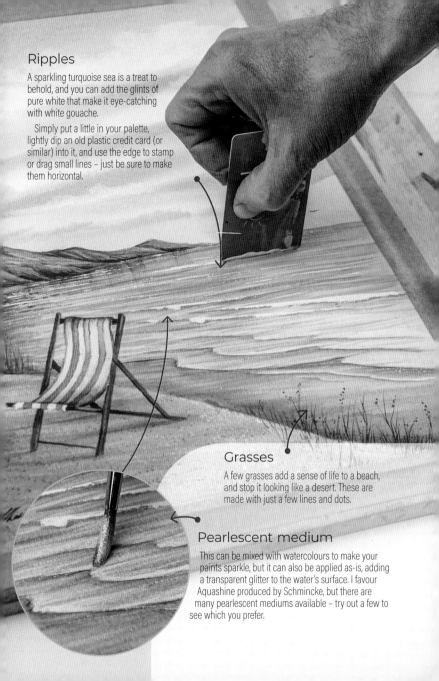

Ripples

A sparkling turquoise sea is a treat to behold, and you can add the glints of pure white that make it eye-catching with white gouache.

Simply put a little in your palette, lightly dip an old plastic credit card (or similar) into it, and use the edge to stamp or drag small lines – just be sure to make them horizontal.

Grasses

A few grasses add a sense of life to a beach, and stop it looking like a desert. These are made with just a few lines and dots.

Pearlescent medium

This can be mixed with watercolours to make your paints sparkle, but it can also be applied as-is, adding a transparent glitter to the water's surface. I favour Aquashine produced by Schmincke, but there are many pearlescent mediums available – try out a few to see which you prefer.

Reflections

A reflection is a direct mirror of the object above. The most successful reflections on water are made up of horizontal ripples made up of the colours of the object being reflected.

It's important not to confuse or mix up reflections with shadows, as beginners often do. Add the shadows only after you've finished the reflections – these are the key to give the reflection a sense of structure.

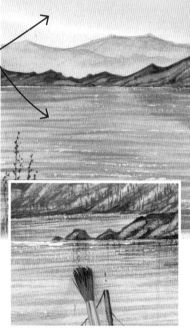

Still water

The sky is reflected in the lake – so use the same colours for both! Note that as the sky fades from dark at the top to light near the horizon, so the lake will be lighter near the horizon and darker nearer to the foreground.

Reflections and objects behind others

Here the tree is behind the building; the reflection shouldn't appear in front of it. Use a scrap of spare paper to ensure you don't work over objects in the foreground.

Adding depth to water

Use a split dry brush in downwards strokes where the water meets the land. Vary the length and avoid uniformity or patterns.

Not a mirror

While the water reflects the sky, it's neither perfectly still, nor perfectly transparent.

To account for this, I've laid a glaze (an extra pale consistency wash) of cerulean blue to vary the hue of the water. I've also broken up the surface with horizontal marks to represent light ripples.

The water's edge

Add contrast with strong grey, followed by opaque white, to apply horizontal lines over the reflection and over the water's edge.

Boats

Painting a beautiful lake scene will give you a tranquil and calm feeling – and adding a boat will give such a picture a focal point. Boats give life and scale to any water scene, whether the open sea or a lake. Beginners often fear painting boats, but here's a very simple approach to help if you're nervous.

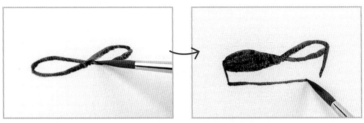

Using a size 6 round brush, mix a medium strength warm grey and a strong shadow grey. Begin with the warm grey and paint an infinity symbol (a sideways figure of 8).

Fill in the left loop with the strong shadow grey, to suggest the inside of the the hull. Add a diagonal line on each side, tapering down towards the centre, then connect these two lines with a horizontal.

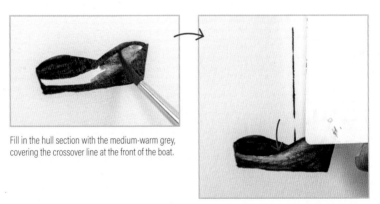

Fill in the hull section with the medium-warm grey, covering the crossover line at the front of the boat.

Using the strong shadow grey, paint this along the edge of a plastic card, and then gently press this onto the paper to give the mast. Any missing sections can be filled in with a size 2 rigger brush.

FOCAL POINT ●

The waterline sits a third of the way up the painting. I've placed the boat's mast crossing this, to give the eye something to rest upon.

We don't normally put the focal point so near the centre, but here it adds to the calm, safe and restful atmosphere.

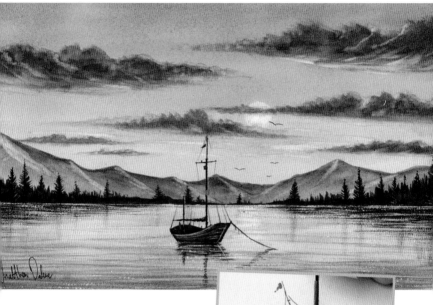

Detailing your boat

You can now add detail to your boat with a size 2 rigger – a brush designed specifically for painting the rigging of ships – and the strong grey mix. Paint in the rigging, mast detail, the rope and the reflection. In the finished painting, you'll notice how the rigging tapers off and almost disappears before it meets the end of the mast.

Using the 6mm (¼in) flat brush and the lift-out technique, you can add highlights to the hull. A craft knife can also be used for scraping away crisper highlights on the mast, hull and reflection.

PAINTING THE RIGGING

To achieve greater detail from a rigger brush, wipe off the excess paint on kitchen paper and hold the brush like a pencil, rest your hand on the paper and paint with the tip of the brush.

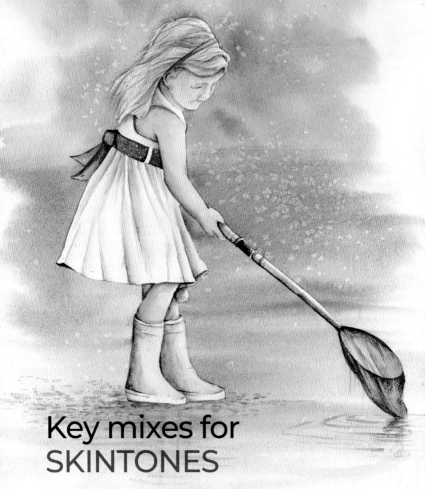

Key mixes for
SKINTONES

If you want to add figures to your scenes – or simply to paint small vignettes like the one on this page – then these mixes will be invaluable. Skintones are endlessly variable, so I encourage you to vary and adjust the proportions presented here. Think of them as a starting point.

Avoid using grey for shadows; use a darker skintone mix instead. The dark skintone mix shown opposite, for example, has been used for shading on the figure shown above. Add more ultramarine blue to the dark mix for the shadows on very dark skintones.

Even if you're not interested in having figures in your scenes, these mixes are useful for things besides flesh: beaches, evening skies, brickwork and terracoatta, to give just a few examples.

DARK SKINTONE MIX

- **5** parts yellow ochre
- **3** parts alizarin crimson
- **2** parts French ultramarine

LIGHT SKINTONE MIX

- **8** parts yellow ochre
- **1** part alizarin crimson
- **1** part French ultramarine

MID SKINTONE MIX

- **6** parts yellow ochre
- **2** parts alizarin crimson
- **2** parts French ultramarine

Figures in your pictures

It's easy to treat figures as something special in your composition, but unless you want them to be the fous of your picture, resist the urge. Instead, treat them like any other object. This ensures that they don't take attention away from the rest of the painting. The ideas here show how to make deliberately simplified figures.

It's important to use transparent colours for painting figures: opaque colours can appear slightly dirty.

Painting a simple figure

THINK 'CARROT'
The figure should taper down to a point; the overall silhouette should resemble a carrot.

CLOTHING
Reserve bright colours for tops; keep trousers more muted.

GROUNDING
Add a shadow to help ground the figure and make it feel like part of the picture – make sure the shadow follows the line of the ground and matches the light elsewhere in your composition.

Painting a simple dog

Start with an 'M' shape; then fill in the top and add details – as simple as that.

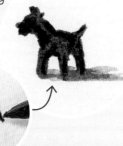

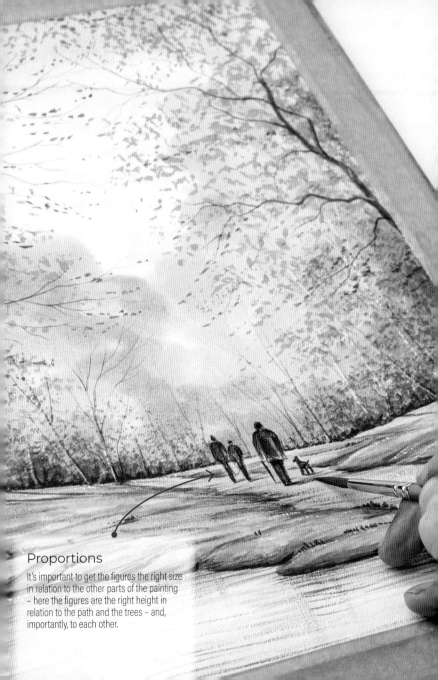

Proportions

It's important to get the figures the right size in relation to the other parts of the painting – here the figures are the right height in relation to the path and the trees – and, importantly, to each other.

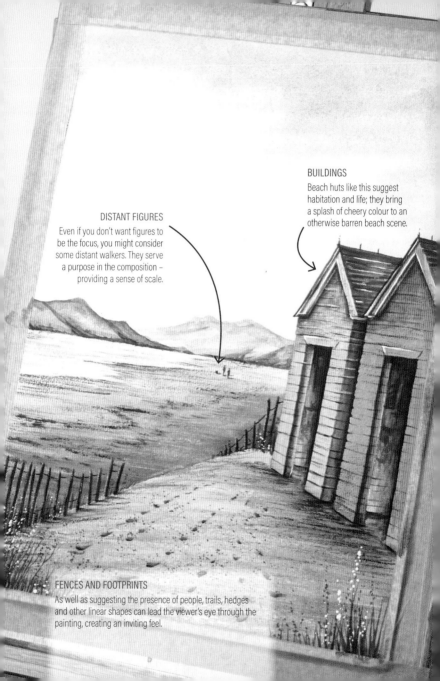

BUILDINGS

Beach huts like this suggest habitation and life; they bring a splash of cheery colour to an otherwise barren beach scene.

DISTANT FIGURES

Even if you don't want figures to be the focus, you might consider some distant walkers. They serve a purpose in the composition – providing a sense of scale.

FENCES AND FOOTPRINTS

As well as suggesting the presence of people, trails, hedges and other linear shapes can lead the viewer's eye through the painting, creating an inviting feel.

Adding a sense of life

Sometimes your composition doesn't warrant including figures as a focal point – they might draw too much attention away from the rest of the scene. However, it's still good to suggest that people or animals have been present, as otherwise you can give a slightly eerie, deserted feeling to your painting.

Here are a few suggestions for how you can add a sense of life to your landscapes without making them the focus of your work.

Footprints

Leading you gently into the painting, a trail of footprints is a great way to suggest the presence of people.

Start by painting a series of U-shapes with a rigger brush and the brown mix, then add dark skintone within the curve of each U. Rinse your brush, tap off excess water, and use the damp brush to blend the colour away as shown.

BROWN extra strong
- **5** parts yellow ochre
- **4** parts alizarin crimson
- **1** part French ultramarine

DARK SKINTONE medium
- **5** parts yellow ochre
- **3** parts alizarin crimson
- **2** parts French ultramarine

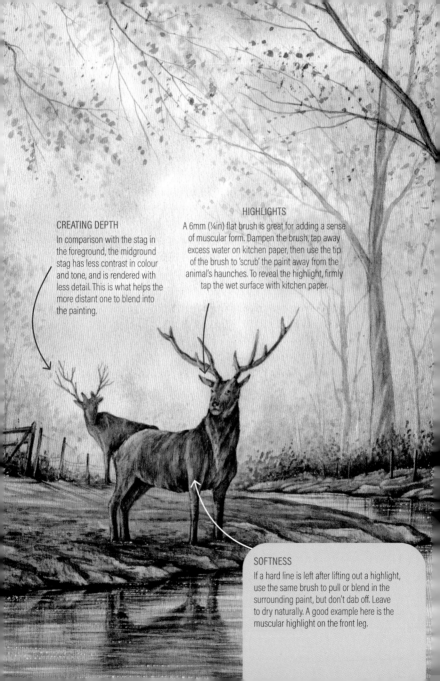

CREATING DEPTH

In comparison with the stag in the foreground, the midground stag has less contrast in colour and tone, and is rendered with less detail. This is what helps the more distant one to blend into the painting.

HIGHLIGHTS

A 6mm (¼in) flat brush is great for adding a sense of muscular form. Dampen the brush, tap away excess water on kitchen paper, then use the tip of the brush to 'scrub' the paint away from the animal's haunches. To reveal the highlight, firmly tap the wet surface with kitchen paper.

SOFTNESS

If a hard line is left after lifting out a highlight, use the same brush to pull or blend in the surrounding paint, but don't dab off. Leave to dry naturally. A good example here is the muscular highlight on the front leg.

Stag in woodland

From a sheep in a field to a bird in flight, animals in the landscape offer a focal point and interest. In this autumnal woodland, the stags form a strong focal point. Large animals offer you completely different options for composition in woodland scenes.

Adding detail

When an animal is your focal point, there's no substitute for careful attention to detail.

- The warm shadow mix and a size 1 or 2 rigger are great for all sorts of detail, from the small dots of the eyes to the nose and mouth.

- Any hard lines can easily be feathered away with a damp brush. Look at the mouth here, for example. It's a hard line on the top and feathered down.

- Extra shadows can be painted in at this stage: on the back inside leg; the side of the head on both stags; and the right side of the legs. Again, blend or feather with a damp brush.

WARM SHADOW strong
- **7** parts burnt umber
- **3** parts French ultramarine

RUSSET strong
- **8** parts burnt sienna
- **1** part yellow ochre
- **1** part French ultramarine

Small animals

Whether sketching a mouse or bird in your garden, or animals at the zoo, the techniques here – of rounded, simple shapes to create the basic structure can be applied to almost any animal. A good tip is to print out an image of the animal you want to draw, and practise the oval shapes on top before trying it on your watercolour paper. This helps to ensure the size and scale are right for your painting.

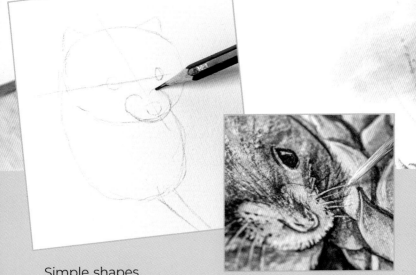

Simple shapes

I started this painting by sketching out two simple circles. I added a horizontal guideline for the eyes and a diagonal one for the tilt of the head/profile, then lightly sketched in the features. The same process can be used to draw virtually any animal – just break it down into the simplest shapes you can.

Whiskers

The secret to whiskers is to taper the lines. Use a rigger and gradually lift the brush away as you make the stroke. Don't make them absolutely straight either; follow a common curve.

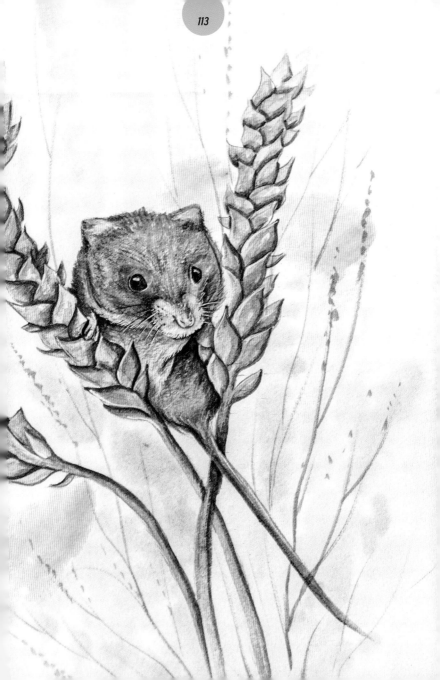

Animals in the landscape

Animals add life to a landscape, and I love painting in a sheep or a cow to add scale and interest to a landscape. Animals can be tricky to sketch, but using these simple oval shapes and lines makes the process simple and very effective.

Each of these examples starts life as a pair of simple 'n' shapes for the legs, to which I add ovals or circles for the body structure. These lines are sketched faintly and used as a guide. Next, more pressure is applied to over-draw the refined shape. My advice to you is to practise sketching animals – whether farm animals or pets – using these basic shapes... it works!

Horse

Cow

Sheep

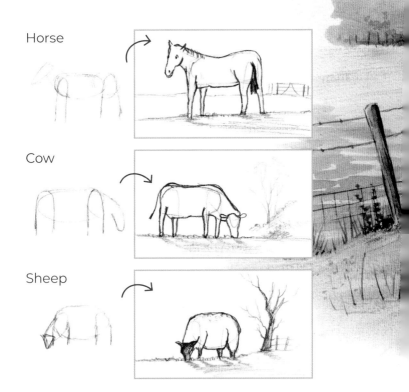

Overpainting with opaque white

Sheep might appear tricky to paint, as they're usually lighter-coloured than their surroundings. Don't worry – you don't have to leave space for the individual sheep at the start of the painting (though you can use the masking fluid technique on page 80, if you wish). Instead, use opaque white to paint the fleece in after you've finished the landscape. You can then use the strong dark to shade the fleece.

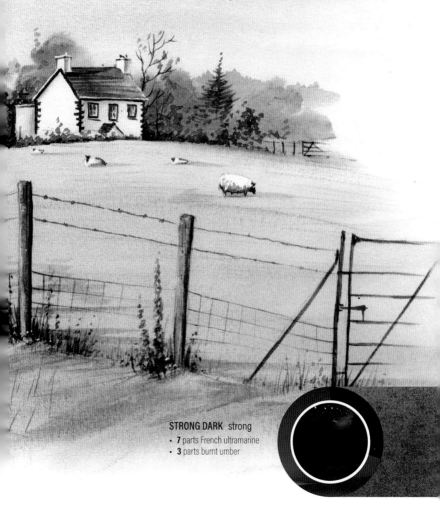

STRONG DARK strong
- **7** parts French ultramarine
- **3** parts burnt umber

Kingfisher

A kingfisher, like most birds, is built up from simple oval shapes.
Everything from the eye to the wing can be sketched from these
basic round shapes, then refined. Adding these characterful birds
to a river painting never fails to give foreground interest.

In this example, I've made the kingfisher the main focus of the
painting – and as a result I've kept the background fairly simple.
You could add a small one as an incidental eye-catching addition
to a larger scene where the river takes centre stage.

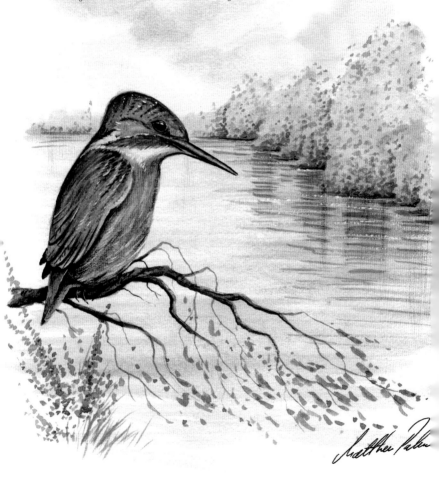

Simple shapes

Cupping the pencil in your hand will help you to make very loose oval shapes. Hold a 2B pencil as shown, so the tip is almost parallel with the surface and creates light marks.

Refining the shapes

Once the oval outlines are in place, hold your 2B pencil closer to the tip, to give you a stronger line, and build up the detail of the feathers and beak using the basic shapes as a guide.

Separating feathers

Use pure cerulean blue for the feathers. Once dry, paint the curve of the feather with the Kingfisher blue shadow mix, then use a clean damp brush to blend the line away from the feather and upwards into the bird. A strong shadow grey (see page 77) can also be used to give more depth. Add white highlights to give greater detail.

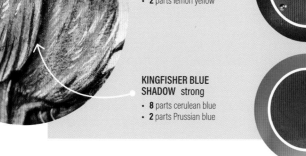

KINGFISHER ORANGE strong

* **8** parts burnt sienna
* **2** parts lemon yellow

KINGFISHER BLUE SHADOW strong

* **8** parts cerulean blue
* **2** parts Prussian blue

Falling snow

One of my favourite subjects is snow, but how do we paint falling snow? Simple: sprinkle salt into wet paint – the salt crystal draws the water in from the wet paint around it, leaving the effect of a snow flake. The wetter the area, the larger the white flake will be.

Salt for sparkles

The first stage is to paint a clear sky (see page 30): wet the background with a large round brush and clean water, then add the paint wet in wet, allowing it to bleed and blend on the surface. Wait a few minutes until the shine of the water on the surface has started to dull, then lightly sprinkle salt onto the surface as shown below. It will take a few minutes for anything to happen, so be patient.

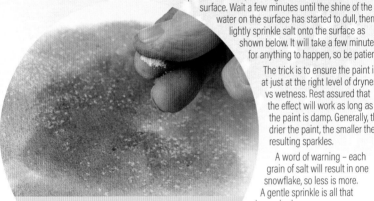

The trick is to ensure the paint is at just at the right level of dryness vs wetness. Rest assured that the effect will work as long as the paint is damp. Generally, the drier the paint, the smaller the resulting sparkles.

A word of warning – each grain of salt will result in one snowflake, so less is more. A gentle sprinkle is all that is required.

WHAT SORT OF SALT?

Simple table salt is best. In my experience, rock or sea salt doesn't work as well.

BRUSH IT OFF

Leave the paint to dry completely – don't be tempted to fiddle while the salt is working its magic. Once completely dry, brush away the salt crystals to reveal the finished effect.

It's a matter of colour

Some colours work well with salt, some won't move. The pigments vary from manufacturer to manufacturer, so it's a case of testing your palette to find works best for you. Colours that I find work well with this technique are:

- Prussian blue
- Cerulean blue
- Dioxazine violet
- Yellow ochre
- Raw sienna
- Burnt sienna.

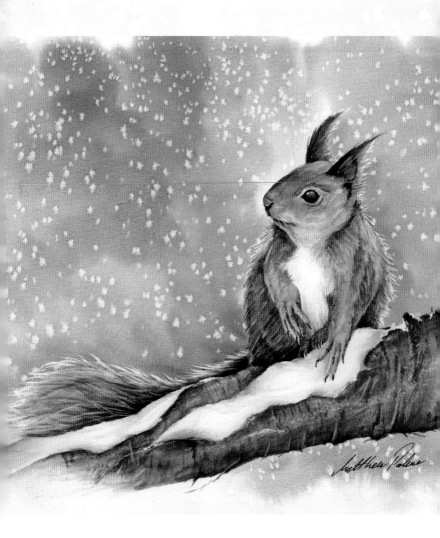

Fixing cauliflowers

Cauliflowers – also called **backruns** – occur when wet paint hits damp paint. The water is quickly drawn through, depositing the pigment it's carrying and leaving an unattractive mark. It can be frustrating when one occurs in a painting that you're otherwise happy with – but don't worry: we can get rid of them.

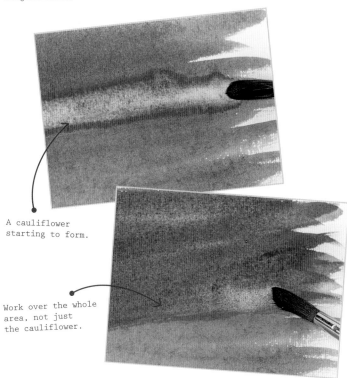

A cauliflower starting to form.

Work over the whole area, not just the cauliflower.

Catch it while it's wet

Cauliflowers start to appear while the paint is still wet. If you spot one forming – as show above left – then it's possible to even out the surface by working over the whole area again while it remains wet. This will minimize or even remove the cauliflower entirely, as you can see above right.

OH NO! It's dry

That's still not a problem – you can gently reactivate the paint by
brushing clean water over the top. Leave it for a few moments,
then gently dab the damp surface with kitchen paper. It will lift
away the reactivated paint and solve your cauliflower.

Splashes and splatters

Splattering paint gives an attractively loose, random effect. It's a technique I've used in many of my paintings to give quick texture and a random feeling. Whether you're painting the gravel in a footpath, a waterfall with spraying mist, or the beautiful stars in a night sky, it's well worth having in your arsenal of painting techniques.

How to splatter

The technique itself is as simple as loading your brush with paint, holding a finger over the painting, and tapping the ferrule (the metal part that holds the hairs in place) firmly onto your finger. This causes the paint to flick off the hairs and onto the surface.

Bigger brushes make bigger splatters. There's subtlety here, however: if your brush is very large, or heavily-loaded, you'll get great spots and splats, while if your brush is too small or dry, or your paint is too strong in consistency, you'll barely get an effect at all.

I tend to use a size 6 round brush: it's the perfect size and creates nice size splatter effects. Hold the brush by the bottom to give leverage and looseness. Gently tap away the excess paint on kitchen paper before you begin, and make sure to point the brush in the direction you wish to splatter when you work.

CONTROL
Hold the brush close to the paper to control the splatter area.

Be subtle: use splashes to enhance, not distract from, the subjects of your painting.

Creating fine spray

Consistency is key. For the distant, fine spray here, I used a extra pale turquoise mix of viridian hue and French ultramarine for the initial splattering. Once that had dried, I applied a separate pale mix of opaque white over the top. Layers of splattering help to create depth in the mist of this famous waterfall.

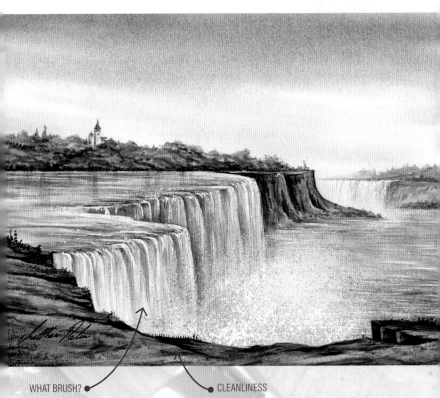

WHAT BRUSH?

A size 6 round, loaded with pale and extra pale consistency paint (see page 15) was used here.

CLEANLINESS

The other secret to successful splattering is to protect any areas of the painting you wish not to be splattered. With experience, you'll come to learn simply how to control the brush to avoid the areas you want to remain clean, but if you're new to splattering, I suggest laying down kitchen paper over these areas before you start.

Leaf stencils

Painting a seasonal still life of a natural forest floor makes for a wonderful painting and gives you the chance to use some great techniques. Start by heading outside and grabbing a few fallen leaves from the trees and plants around you – I'm sure they won't mind.

Stencils are a great way to build up subtle texture and shape in a background.

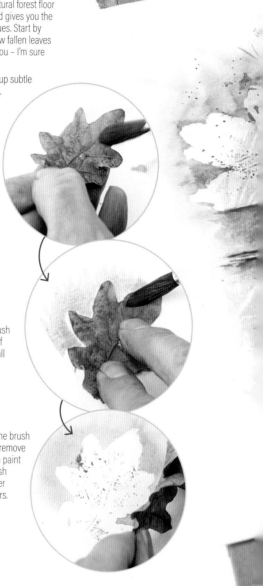

Dry brush

Load your brush, then remove excess paint on a piece of kitchen paper until there is barely any left on the hairs. Lightly draw it over the underside to put a little paint on the leaf.

Press and paint

Turn the leaf over and place it face-down on the surface. Load your brush and paint from the centre of the leaf outwards onto the paper, working all around the leaf.

Blend and reveal

While the paint is still fresh, clean the brush well, tap twice on kitchen paper to remove excess water, then blend the brown paint away from the leaf. Refresh the brush with water if needed to blend further until the edge completely disappears. Carefully lift the leaf away to reveal the result.

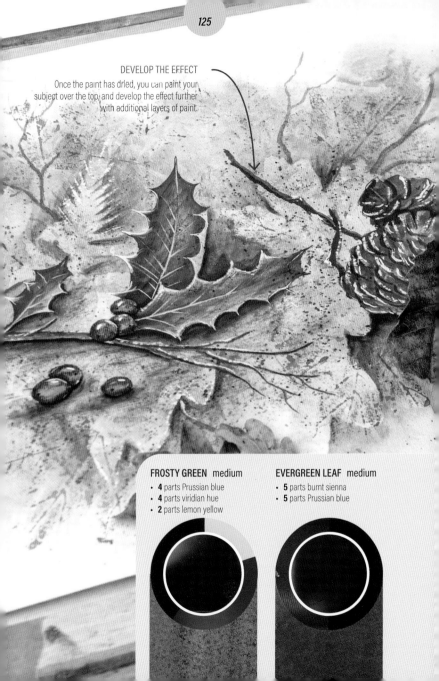

DEVELOP THE EFFECT
Once the paint has dried, you can paint your subject over the top, and develop the effect further with additional layers of paint.

FROSTY GREEN medium

- **4** parts Prussian blue
- **4** parts viridian hue
- **2** parts lemon yellow

EVERGREEN LEAF medium

- **5** parts burnt sienna
- **5** parts Prussian blue

Beams of light

There are few sights more magical in the woodland than the light from a low sun breaking through the mass of trees. It seems like a tricky effect to capture, but the truth is that it couldn't be easier.

Rather than trying to paint the light effect in from the start, paint the woodland as normal, allow it to dry, then use the following tips to bring in the sunlight.

Reactivating paint

Many watercolour paints can be 'reactivated' by wetting them – the pigments lift off the surface and can be adjusted or removed. Only try this on paint that is completely dry – otherwise you risk creating a muddy mess!

Note that some paints, such as cadmium red and Hooker's green, are staining colours (this will be noted on the tube or manufacturer's website). Where non-staining colours sit on the surface, staining pigments work into it. As a result, they are much more difficult to reactivate and lift off. This technique works best with non-staining colours.

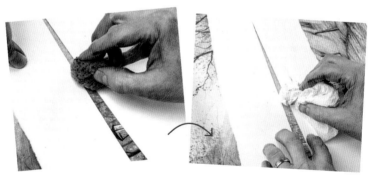

Use two strips of paper to protect the rest of the painting, placing them to leave uncovered the area in which you want the beam of light. Use a damp ethically-sourced sponge to gently wet the surface. Just dab – don't scrub.

Use clean kitchen paper to dab the surface and lift off the wet reactivated paint. Again, tap the surface lightly, and don't rub it. Lift away the paper strips to reveal the result.

FADING AWAY

Lift away less paint further from the light source, to allow the light beams to dissipate.

LIGHT SOURCE

All the beams of light should all come from the same point. You can either have the sun as part of your painting, as here, or your beams of light can come from off the page – just make sure they all align and point towards the same place off-page.

CONSISTENCY OF SHADOWS

Make sure any cast shadows follow the same direction as the light beams.

Cauliflower Also called a backrun, this is the unsightly effect caused when you apply more paint or water to an almost dry or damp area. Generally considered a mistake.

Composition How a scene is formed, making it pleasing to look at.

CP Short for 'cold-pressed', also called 'Not'. Refers to a paper with a lightly textured surface.

Dry brush Dragging a lightly-loaded brush over the paper to pick up the texture.

Focal point The main part of the painting, the area you want to viewer to see.

Glaze A transparent wash of watercolour paint, applied over the top of an area previously painted to change the tone or colour.

HP Short for 'hot-pressed'. Refers to a smooth paper surface.

Layering Adding washes of paint over the top of dry paint.

Lifting out Dabbing kitchen paper on a wet or reactivated surface to remove some paint and create highlights.

Masking Protecting an area to keep light or the original paper colour. This can be done with masking fluid or masking tape.

Negative painting Painting around a light area, to create the impression of a shape.

Opaque Describes paint with large pigment particles that does not let light through. Good for overpainting.

Overpainting Using opaque colour to paint over an existing dry area.

Reactivating Agitating dry paint with a damp brush to make it workable again. Good for lightening an area, this only works on stronger paint areas and with certain paints.

Splattering Tapping a loaded brush over your fingers, causing paint to create random marks on the surface.

Stippling Repeatedly tapping the upright tip of a brush on the paper.

Subject The theme or object you decide to paint.

Transparent Describes paint with small pigment particles that allow light through. Good for luminosity and layering effects.

Rough Very roughly textured paper surface.

Wash A flat, wet on dry application of paint.

Wet into wet Adding paint to a wet surface (either water or wet paint); allowing the paint to mix and move on the surface.

Wet on dry Applying paint directly to dry paper.

First published in Great Britain 2022 by
Search Press Limited, Wellwood, North Farm Road,
Tunbridge Wells, Kent TN2 3DR

Reprinted 2023

Text copyright © Matthew Palmer 2022
Photographs by Mark Davison at Search Press Studios
Photographs and design copyright © Search Press Ltd.
2022

ISBN: 978-1-78221-948-4
ebook ISBN: 978-1-78126-945-9

Suppliers

If you have any difficulty obtaining any of the materials and equipment mentioned in this book, visit the Search Press website for details of suppliers:
www.searchpress.com
You are invited to the artist's website:
www.watercolour.tv